Modeling Life

MODELING LIFE

*Art Models Speak about Nudity,
Sexuality, and the Creative Process*

SARAH R. PHILLIPS

STATE UNIVERSITY OF NEW YORK PRESS

Cover: 1905 Life Modeling Class, Art Institute of Chicago,
photo archives of Alex Blendl.
Photos of life drawing classes by David Friedman.

Published by
STATE UNIVERSITY OF NEW YORK PRESS
ALBANY

© 2006 State University of New York

For information, address
State University of New York Press
194 Washington Avenue, Suite 305, Albany, NY 12210-2384

Production, Laurie Searl
Marketing, Fran Keneston

Library of Congress Cataloging-in-Publication Data

Phillips, Sarah R., 1963–
 Modeling life : art models speak about nudity, sexuality, and the creative process /
Sarah R. Phillips.
 p. cm.
 Includes bibliographical references and index.
 ISBN-13: 978-0-7914-6907-1 (hardcover : alk. paper)
 ISBN-10: 0-7914-6907-7 (hardcover : alk. paper)
 ISBN-13: 978-0-7914-6908-8 (pbk. : alk. paper)
 ISBN-10: 0-7914-6908-5 (pbk. : alk. paper) 1. Artists' models. 2. Artists' models—
Oregon—Portland—Attitudes. I. Title.

N7574.P47 2006
702.8—dc22

 2005037172

10 9 8 7 6 5 4 3 2 1

Contents

Preface

Since beginning my work with life models, the question that I've been asked most frequently is: "How did you get interested in doing research on *that?*" The voices of the people asking suggest that they expect to hear a titillating story. Most people, I've discovered, have a romantic and sexual picture of what goes on between a life model and an artist in a studio. They picture a young, female model and an older, male painter. They picture the painter gradually seducing his naïve model in some made-for-Hollywood "sexual awakening" story. As is so often the case, the truth is much more mundane.

I began thinking about life models while I was completing my postdoctoral appointment. At the time, I taught criminology courses for the Department of Sociology at Yale University, including one very large class of undergraduates. The class met Tuesday and Thursday mornings, and on Tuesday evenings, I attended figure-sculpting classes. Not an artist, I was taking beginning sculpting classes as a way to relax in the evenings. Midway through my second term, the figure sculpting class began working with a new model, a young woman who would be posing nude for the class for the next five weeks. I noticed nothing unusual about this model as she discarded her robe and assumed a reclined pose. About fifteen minutes into the session, however, the model changed her pose, and we happened to make eye contact. It was then that I realized I knew her: earlier that day, she had been taking notes in the front row of my criminology lecture.

For the first time, I felt awkward and embarrassed. I was no longer looking at a nude model, I was looking at one of my students naked, a student to whom I would have to assign a grade in just a few weeks. In retrospect, this need not have been a problem if I had simply confronted the awkward situation and discussed how to handle it. Instead, I responded with striking immaturity: I never returned to my figure sculpting class, and the model/student moved her seat to the very back row of the lecture hall. Neither of us ever said a word about it.

What had suddenly turned my nude model into a naked girl? How had my artist's gaze transformed instantly into that of the voyeur? And what was a Yale student doing undressing for money, anyway? This book represents the culmination of the research journey sparked by these questions. Over a ten-year period, I have read about models, interviewed current and former models, and spent countless hours watching life models work in schools and studios. I am not a life model, and I do not presume to speak for all life models. Nor am I an artist. My husband, David Friedman, is an artist, but with the exception of taking the photographs for this book, his work has not taken him to the life studio for many years. There are many fine works about artists, their practices, and how we typify both artists and the artistic endeavor. In this book, I have not sought to portray the artist's perspective. I have, instead, focused my attention narrowly on contemporary life models in the Western art tradition. Unlike artists, life models have rarely been asked to explain their work. In this book, I have tried to give them a chance to speak for themselves and in their own words.

Acknowledgments

The earliest stages of this research were supported by small grants from The Foundation for the Scientific Study of Sexuality and a Meyer Grant from Pacific University. I am grateful to the University for providing me with sabbatical funding so that I could complete this project.

My thanks to Nancy Ellegate, senior acquisitions editor at State University of New York Press, for her continued interest in my project, and Laurie Searl, senior production editor, for her patient guidance.

Over the course of ten years, several Pacific University undergraduate students helped with parts of this project. In particular, I appreciate the many hours of tedious transcription done by Laleña Dolby, Laurel Martin, and Anne Sinkey. These students occasionally helped with interviews and presentations as well.

I am grateful to my husband, David Friedman, and friend Dan Kvitka for their photography and help in preparing images for this book.

My parents, Joan and Rich Phillips and Kay and Howard Friedman, and my sisters, Kate and Liz, have followed the long path of this work. I am always appreciative of my family's love. My sister Kate Phillips, a writer herself, spent many hours reading and editing drafts. She, especially, has given me unwavering kindness and encouragement over the years.

Thank you, David and Eliza, my three-year old daughter, for your love and support, even when that support comes in the form of snatching and hiding the pages as they come off the printer. You make me happy every day. Madaline Derden and Mara Sobesky provided loving care for Eliza while I was working. Nancy Breaux and Liz Johnston did their best to keep me sane.

Of course, I am most indebted to the life models of Portland, Oregon, for their time, trust, and willingness to help. I am especially grateful to Jeff Burke, of Hipbone Studio, for going so far out of his way to help. Jeff and Eliza, another Portland model, posed for the photographs in this book. Without their help, and that of all the models I met and interviewed, this book would not have been possible.

ONE

Assuming the Pose

An Introduction to Life Modeling

[Nude modeling is] a site for irreconcilable notions about nudity in art (good) and nudity in life (bad). For while the painting of the nude was respected, the unclothed lady who modeled for it was not.
—Borzello, *The Artist's Model*, 73

A 43 year old art and religion teacher at a Catholic high school has been asked to resign over his outside job: he moonlights as a nude model. The Rev. Michael Billian, Pastor and President of the school said "he didn't object to nudes, such as Michelangelo's paintings in the Sistene Chapel, but posing for such art is inappropriate for a high school teacher."
—*The Oregonian*, June 13, 1996

LIFE MODELS

ACCORDING TO ANCIENT Greek and Roman mythology, the sacred streams dancing down the sides of Mount Helikon and Mount Parnassos were home to nine nymphs, the daughters of Zeus and Mnemosyne, collectively called "the Muses." The Muses presided over music and song, poetry, and the fine arts. Mortal artists worshipped the Muses, dependent upon their guidance and approval for creative inspiration.

Today, the source of artistic creativity and inspiration remains largely mystical, unexplained by modern science. Nonartists tend to think of artistic creativity as inborn. Some people, we say, have artistic talents and sensibilities,

1

and some simply do not. How or why it is that some people are born with artistic talents is a mystery to us. What's more, even a talented artist, we believe, cannot create great works of art in the absence of inspiration. What allows or causes or prompts inspiration, however, is inexplicable.[1] Contemporary artists struggling to find inspiration still seek out muses. Rarely water nymphs, today's muses are more likely to be ordinary men and women. A life model acts as a muse, some sort of mysterious font of incalculable inspiration for an artist, who will, via some process we cannot really know or understand, turn that inspiration into art. Once worshipped for their ability to inspire, today's muses are often disdained as little better than strippers. And, while the nine muses of Mounts Helikon and Parnassos were ruled by Apollo, the god of oracles, contemporary muses are believed to be ruled by a more earthly force: sex.

In reality, the men and women who pose nude for artists and art classes, while respectful of artists' talents and what they call the "artistic process," see themselves and their work in far less romantic terms. Life models believe that a figure artist's sense of inspiration comes as the result of hard work on the part of his or her model. What's more, one does not simply wake up to discover that one is a muse. Good models are made, not born. Life models are aware that society looks with scorn upon their profession, but they are called to the work of a muse anyway. They hope that while their contemporaries may not respect them, people will one day look with honor and admiration upon the results of their work.

Little has been written about mortal muses. Most library collections of art history and analysis include multiple titles concerned with the depiction of the nude but few titles related to who that nude might have been. Although some art historians make reference to artists' models, most in fact are describing the depiction of models in art and changes in the representation of the nude, not the living person who posed for those depictions.[2] When authors have focused on life models, they have rarely gathered their information directly from the lived experiences of life models. France Borel's *Seduction of Venus: Artists and Their Models* and Frances Borzello's *Artist's Model* offer historical accounts of life models, notable for their careful and sympathetic writing, but neither work offers models' own words and explanations.[3] Exhibition catalogs, such as that written by Martin Postle and William Vaughn to accompany the 1999 exhibit The Artists Model in England or Dorothy Kosinski's *Artist and the Camera* published by the Dallas Museum of Art to accompany a 2000 exhibit there, offer some of the most detailed information about specific life models.[4] There also exist "technical writings" directed at artists, which focus on artistic technique and mention models indirectly as aids to achieving particular effects.[5] For example, in his guide to *Modeling and Sculpting the Human Figure*, Edouard Lanteri advises artists to give a model frequent rests so as to prevent the model's pose from subtly shifting or drifting due to fatigue.[6]

It is not unusual to encounter life models in fiction. The nineteenth century, for example, produced Honoré de Balzac's *Le chef d'oeuvre inconnu* (1845), Émile Zola's *L'Oeuvre* (1886), Henry James's *Real Thing* (1892), and George Du Maurier's *Trilby* (1894). In popular accounts, the depiction of life models is highly romanticized and often takes a sexual tone. For example, the 1920s American magazine *Artists and Models* featured nothing about either artists or models in its text, offering instead pictures of chorus girls.[7] In 1929, Alice Prin, a.k.a. Kiki of Montparnaasse, celebrated model for Man Ray among others, published her memoirs, which were reprinted in the United States in 1950, including an introduction by Ernest Hemmingway.[8] In *The Education of a French Model*, Kiki shares the "loves, cares, cartoons and caricatures" of her life. Artists and models were a popular theme in some of the most famous erotica of the twentieth century, such as *Little Birds* written by Anais Nin,[9] and more recently, in such critically acclaimed films as *Angels and Insects*. Even the popular 1990s television show *Ally McBeal* featured a story line in which the lead character had a sexual encounter with a life model.

Historical and biographical accounts, such as C. J. Bulliet's 1930 work, *The Courtezan Olympia: An Intimate Survey of Artists and Their Mistress-Models*, focus on real or imagined sexual liaisons between artists and their life models. Thus, Modigliani's model and mistress, Jeanne, is said in many accounts to have killed herself just one day after the artist died, brokenhearted by his absence.[10] Monet and Bonnard both married their models. Lydia Delectorskaya acted as nurse, housekeeper, secretary, companion, and model for Matisse,[11] and even people unfamiliar with Andrew Wyeth's work may know about his fifteen-year-long relationship with his model, Helga Testorf. The popular conceptualization of the model-as-mistress takes two forms. First, the life model may become the artist's mistress over the course of a sitting. Alternately, there is a common belief that when an artist depicts a beautiful woman in his work, she is probably his mistress.[12] That is to say, the mistress becomes the model.[13] In either case, it is assumed that life modeling involves some degree of sexual activity, and little effort is made to understand modeling as actual life models experience it. As writer and art historian Frances Borzello has claimed, "What is certain is that in the transition from fact to fantasy, the mundane work of modeling has been transformed into a profession of bohemian gaiety and glamour. And the reality of ordinary-bodied men and women posing for poor pay in a local art college has been lost in a mass of notions about models as mistresses, models as inspiration and models as naked and female."[14]

As a profession, life modeling seems to be strangely invisible to most of us. Although we have all seen paintings and sculptures of people, either in museums or galleries, on television, or in books, few of us have stopped to consider the men or women whose job it is to sit for artwork.

AESTHETIC FASHION AND THE
PROFESSION OF LIFE MODELING

Not all artists use life models. Working from life is only necessary if an artist wants to depict the human form, and even then, only if the artist wishes to depict that form in what contemporary society recognizes as a "realistic" way.[15] An artist who does not draw or sculpt people, whose work is abstract, or who works primarily from his or her own imagination need not necessarily refer to a living human being in creating his or her work. Therefore, historically, the importance of life models to the artistic process has waxed and waned with changing fads and fashions in artistic production.

There are scattered accounts of commissioned artworks that involved life models in ancient times. For example, there is the legend of the Greek painter Zeuxis, who was commissioned by the people to paint Helen and was given his choice of the most beautiful virgins of Crotona to serve as his model.[16] In addition, Roman histories recount Apelles's commission to paint Alexander the Great's favorite concubine in the nude.[17] Nevertheless, the dominant aesthetic of the time was one of idealization and generalization, not of realism or particularism. Artists subscribing to an idealistic aesthetic would strive to create a painting or sculpture that would capture the essence or greatness of Man, not the likeness of any particular man. The particular man carries with him the flaws inherent to being human: blemishes, muscular or skeletal idiosyncrasies, and so forth. As depicted in idealistic art, Man has no such flaws. Idealized images do not demand careful study of a life model. In trying to capture the essence of the ideal man, ancient artists worked more from the idea of Man, and less from an actual man.

The Renaissance, however, ushered in a gradual turning away from the supernatural and a turning toward the natural and worldly. Following a new ideology of empiricism, painters and sculptors started looking to the living people around them to serve as models for their artistic work, rather than working from an ideal, and the profession we recognize as life modeling was born. Historian John Moffitt emphasizes that the "naturalism" of the time described both form and content. That is, naturalism influenced both the artist's style and his or her choice of subject matter. Moffitt sums up the naturalistic approach as "looking at the rose through world-colored glasses."[18] Early in the Renaissance, models worked primarily in individual artists' studios or homes and outside of the accepted, recognized artistic community. But a turning point in the history of figure drawing and life modeling occurred when state-supported art academies in Italy decided to offer training for painters and sculptors and included living models in the coursework. In fact, Italy was home to the first official art academies, the Academia del Disegno in Florence in 1563 and the Academia di San Luca in Rome in 1593.[19] According to art historians Ilaria Bignamini and Martin Postle, early acade-

mies of art could be divided into two categories: those created by the state as "part of a system of cultural institutions designed to serve the policy of the central power," and those created by individual artists in response to market demand.[20] The history of life modeling is inextricably entwined with the history of the early state-supported academies. Private studios isolated artists and were highly dependent upon the abilities and reputations of individual masters. Official academies, in contrast, brought together a group of artists, all working under the same instructors, provided a common vocabulary, and the sense of community prerequisite for the birth of a national pictoral school.[21] Typically, the academies offered a sequence of courses in which artists began their figure studies by copying their professor's drawings or by drawing from casts of Greek or Roman statuary. They then progressed to drawing from a live model as their skills advanced.[22] Although the presence of nudes remained scandalous in many schools, where artists were restricted to working from casts, the state academies' acceptance of working from life went far to establish working from nude models as a legitimate part of artistic training. No longer were artists expected to depict the ideal image of man but instead to portray particular men as realistically as possible. By the close of the Renaissance, drawing from the nude became *the* essential part of artistic training and the regular use of life models in academies spread across Western Europe, from Italy to France, Germany, and England. The earliest record of the employment of models in England was in Sir Godfrey Kneller's Great Queen Street Academy, opened in 1711. In 1722, the academy on St. Martin's Lane ran an advertisement announcing training "for the improvement of painters and sculptors by drawing from the naked."[23]

Unlike today, the majority of life models working during the Renaissance and into the Victorian era were male. A number of private studios and individual artists employed female models, but it was not until the second half of the nineteenth century that most of the state-funded academies in Europe began to admit female models. They would not admit female artists until even later. English academies were an exception, admitting female models as early as the eighteenth century. Historian Nikolaus Pevsner speculates that the fact that the Royal Academy in London was the first official academy to allow female models is best understood not as a reflection of progressive thinking or artistic goals, but as a reflection of the academy's unusual non-governmental nature.[24] Although permitted, the use of female models in state academies in England remained controversial and exceptional. In fact, as late as 1860, Charles Adderly, MP, proposed that Parliament withdraw funding from any school employing nude female models.[25] And Frances Borzello notes that on the rare occasion that a woman did pose for the academy, during the late nineteenth century, "No outsiders except the royal family could enter the life class when a female model was sitting, and attendance was forbidden to students under twenty unless they were married."[26] It was not uncommon, in

fact, for studios and academies to use male models as substitutes for the female, or for elements of an idealized male body to remain apparent in paint-ings of women's bodies.[27]

Generally speaking, the existence of art academies helped to legitimate the role of models and, thereby, improved their social standing. In part, this was due simply to an increase in the number of people studying art both in the academies and in teaching ateliers, which grew in size and prestige throughout the century.[28] Ateliers, begun in France, were large studios offer-ing intensive instruction in drawing and painting under the supervision of eminent artists and professors of the Ecole des Beaux-Arts.[29] Demonstrating the increasing public appearance of life models, a male model known as Mon-sieur Suisse founded the Académie Suisse on the Ile de la Cité, Paris, where Cézanne, among many others, trained.[30] Still, most people continued to think of life models as being of lower class and questionable character. Women who modeled were often considered the social equivalent of prostitutes. To be fair, many early models *were* actually prostitutes, or members of other impover-ished or discredited groups, a reflection of the aura of scandal attached to life modeling at the time and the assumption that only people with no other options would take such work. But the negative perception of models also reflected artists' desires to adhere to a more naturalistic aesthetic. For exam-ple, Caravaggio's work *The Gypsy Fortune Teller* is modeled on a gypsy woman who happened to pass the artist on the street. Caravaggio liked the gypsy woman both because she was readily available and because she represented a rejection of the "beautiful" models preferred by his predecessors.[31] Likewise, van Gogh is well known for his insistence on painting ordinary people and may have intentionally sought out unattractive models.[32] Although far from good, the reputation of male models was somewhat better than that of females. In a broadly patriarchal world, women were devalued; male bodies remained the standard for artists of the time. The fact that female models were barred from many state academies meant that artists wanting to employ them had to secure their sittings in private, further contributing to the sus-pect nature of female models' reputations.

In truth, life modeling was not particularly sought-after or profitable work for men or women. In England, for example, only the very poor would consider posing for payment, and payment was small.[33] Artists negotiated prices for different poses. In France, around 1850, a model might earn four francs for a four-hour session, though some particularly prized models could fetch as much as six francs.[34] Adding to a lack of profitability, modeling work was sporadic. Men were only able to begin securing full-time work as life models during the Victorian period in England, as middle-class homes sought to display their class standing through the acquisition of paintings.[35]

In the late nineteenth and early twentieth centuries, the bohemian com-munity of Montparnasse became a center of European artistic activity, and

both men and women came to the city looking for work as life models. A striking number of these men and women came from Italy. Central to the bohemian image, which spread across Western Europe and England, was the dubious image of a sexually aggressive, heterosexual male artist and a correspondingly sexually submissive, female life model/mistress. Although the vast majority of life models never fit this image, the bohemian notion of the model as female, as mistress, as seductress was too powerful to fade, even coming to reshape the public image of life models as female, rather than male.[36]

Bohemia served to replace outright social rejection of life models with a more nuanced social rejection tinged with sexual intrigue and titillation. The figure of the life model began to appear in the culture more widely, in its bohemian female/mistress guise. In 1894, for example, a South London music hall, the Washington, ran a sketch by Owen Hall titled *An Artist's Model, o' Eve before the Fall*, which toured the United States in 1896. And, in 1912, a play titled *The Model* by Agustus Thomas opened at the Harris Theater in New York.[37] In the public's mind, life modeling became ever more firmly associated with nakedness, strangers, and an exchange of money, a combination that looked a lot like prostitution. In fact, in some parts of the United States, brothels were given the name of "model studios," touting models for photographers or painters, as a cover for prostitution.[38]

In 1837, the National Academy of Design in New York became the first school in the United States to offer drawing from life models.[39] But, even as the practice of working from nude models became common in European academies, the moral climate of the United States during the eighteenth and nineteenth centuries made it difficult or impossible for most artists to work from nude life models. In chronicling the study of the human form in Philadelphia and the depiction of the nude in American art history, David Sellen notes that even in the nineteenth century, students of the Pennsylvania Academy of the Fine Arts had to turn to prostitutes or their fellow students to find anyone willing to pose nude.[40] Indeed, nude models were considered so scandalous that as late as 1886, Thomas Eakins was given the choice of ceasing to teach figure drawing from nude models or resigning his position at the Pennsylvania Academy. He resigned.[41]

Despite pockets of moral condemnation, the bohemian era represented the peak of artistic interest in life models. To be a serious artist in the bohemian community was to paint nudes. And although their reputation remained questionable and their pay poor, there was work to be had by life models, male and female. After World War I, however, the French government began requiring all foreigners to register with the police, and as modeling was not considered an official profession in France, Italian models did not have regular working papers. They were required to return to Italy.[42] By this time, the ateliers of France had become "deeply clichéd, the resort of gauche art students from Britain and America clinging to the remnants of a bygone

educational regime."[43] The official art academies that played such an important role in establishing life drawing as essential to artistic training were in decline. And most importantly, the dominant artistic aesthetic of the day was changing, away from naturalism now, to expressionism and abstraction.[44]

Once again, the skills of the life model became superfluous. Expressionism, pioneered by such artists as Munch and van Gogh, stressed the portrayal of the artist's emotional state over his fidelity to visual reality. Gradually, painting and sculpting became accepted as an expression of the artist, rather than as a depiction of nature. This does not mean, of course, that artists no longer painted human figures or recognizable objects, but the artist's goal was no longer to depict those objects in perfect mimetic fashion. Rather, the goal was to show how the objects looked to the artist, how the objects made the artist feel, or to provoke an emotional reaction in the viewer via the work's composition.

Following the Second World War, in the United States, abstraction emerged as the major art movement of the time. Artists such as Jackson Pollock, Franz Kline, and Mark Rothko stressed the importance of process, immediacy, and the unplanned in their artwork. Abstract artists used painting and sculpture to capture the workings of the unconscious mind. Rarely did this require careful or prolonged reference to a life model, so the demand for models further diminished. To be sure, there remained a core of "traditional" artists who still worked closely from life models, but abstract painters who did work from models typically used the model to develop ideas for images, rather than as a figure to be closely copied. Thus, even when used, the visible impact of life models on finished work declined.[45]

In the second half of the twentieth century, many art schools stopped requiring life drawing as the foundation of all artistic training, and the fortunes of life models further dwindled. Elizabeth Hollander explains that twentieth-century artists tended to deal idiosyncratically with the human figure, "experimenting with different, often isolated, aspects of the figural presence in their images, eventually abandoning any suggestion that the coherence of a figure on a canvas derived from any physical body other than their own."[46] Life modeling in the United States and much of Europe was once again part-time work, now primarily for women. Male models found little demand for their skills. The rise of photography, especially commercial photography, allowed new ways to efficiently capture an image, and contributed to the decline of life modeling as a trade. Commercial and fashion modeling rapidly overtook life modeling. Manufacturers or retailers no longer had to employ life models to pose holding their products while artists drew or painted: photographs made quick and cost-effective advertising. Interestingly, a tension or antipathy between life models and photographic media remains today.

Nevertheless, the profession of life modeling has survived. Anywhere in the United States where an art school, art classes, or art studios exist, you will

find men and women working as life models. In 1993, Robert Speller of *The New York Times* noted that life models "seem curiously archaic, relics of a bygone age when art students labored amid skeletons and anatomical charts, learning to draw the human body as painstakingly as medical students learn to dissect it. . . . Nonetheless, like waiters, these models are something New York never runs out of."[47]

CONTEMPORARY LIFE MODELING IN THE UNITED STATES

Although no longer considered essential to all artistic training, the use of life models is generally accepted as a necessary step in mastering the particulars of human anatomy and proportion. In some ways, drawing from life models remains a mark of the "real" artist. Thus, historian Elizabeth Hollander notes that models have "come to stand in some way for the value of technique itself, not just the ability to render, but the very discipline of seeing."[48] And Kenneth Clark, famed art historian, believes that drawing the nude figure remains the primary link to our artistic past.[49]

For most life models today, modeling is a part-time job, a few hours a week or month that supplements some other, more regular source of income. By all accounts, the majority of contemporary models are women, although in some cities the relative scarcity of male models means that men can find more regular modeling work than women can. In Portland, Oregon, where I live and conducted my interviews over a two-year time period, about 60 percent of the life model workforce was female. I conducted formal interviews with thirty life models, by all accounts, a majority of the models actively working in Portland at the time. I spoke informally with many more active and former models from the Portland area and beyond. Most of the models I met were young, between the ages of eighteen and forty, although I also spoke with models who were still working well into their sixties. In the United States, most studios and schools will not hire models under the age of eighteen, for fear of prosecution under child molestation or child pornography laws. The youngest children are intrinsically poor candidates for life modeling since they tend not to remain still for any extended period of time. Nevertheless, I did speak with one model who said that she occasionally worked with her three-year-old daughter, but this was clearly an exception for her and for models in general.

Historically, many life models sought the protections and legitimacy offered by the academies. But contemporary models in the United States often prefer working in artists' private studios. Private studios typically offer better working conditions, better pay, and a more skilled artist. Opportunities to work privately, however, are rare, especially in smaller cities, so models make most of their income posing for groups in open studio sessions and art classes.

Most group sessions begin with a series of short poses, about ten to fifteen "gestures" that last about a minute each for drawing or a few minutes for sculpture. For the artists, this is a chance to learn to see movement, proportion, how bodies occupy space. Artists do not try to make complete depictions of what they see but rather to capture the essence of the body or gesture in space. For the models, gestures are the most athletic of their poses. Models will create poses that they would be unable to sustain for longer periods of time, such as extreme twisting, balancing, or holding an arm in the air. Gestures are usually followed by a group of three to five slightly longer poses, held for about five minutes. This gives the artist a chance to focus on particular parts of the figure in motion. Models usually have a repertoire of five-minute poses that are still quite athletic but that can be maintained longer than those of the first series. As one model explained to me, "*Those poses can still be pretty dynamic, but you probably wouldn't want to hold a chair over your head.*" Five-minute poses may be followed by a group of fifteen-minute poses or a longer, half-hour to forty-five-minute pose. Most sessions conclude with a longer pose. The entire session may last about three hours. A model may pose once for a group or many times, maintaining a single pose for hundreds of hours, over the course of weeks or months.

Although artists or instructors may request a type of pose, such as standing or reclining, for most sessions the life model plans the poses that she or he assumes for the group. In an odd cycle of art-inspires-life-inspires-art, today's models often try to take poses like ancient statuary. Once in a pose, the model is faced with the challenge of creating the energy or experience from which great works of art might emerge. For most life models, this means somehow rising above the passive object of the artists' gaze to become an active muse.

TWO

Returning the Gaze

Objectification and the Artistic Process

───────────────

WHAT IS ART?

I ENTERED MY RESEARCH with what I thought was a clear understanding of the relationships among the actors and objects of the art studio. In my understanding, there was first an artist. The artist (a man or a woman) would manipulate various materials (paint, chalk, clay) into a particular object (a painting, drawing, or sculpture). That resulting form or object was "art." In this schema, life models are one of the many tools that artists might employ in order to perfect their work. As such, models are not creators themselves, but like a paintbrush are something from which somebody else creates. In my vision of the art studio, life models appeared passive and objectified—both in the sense of serving the function of an inanimate object and in the sense of being the object of another's gaze and agency. It did not take very long, however, for me to learn that these are not the relationships or roles that life models experience in the art studio.

Many life models speak of art as a verb, as something that is *done*, not some *thing*. In this view, art is ephemeral, a moment of inspiration or creation. The object that results from that moment is a by-product, a representation or reminder of what the moment of art contained. Clearly, the tangible outcome of a studio session matters and can be of high or low quality. But it is art only to the outside world, the world that deals in material capital. True art, life models explain, cannot be bought, sold, or transferred. It is something processual, rather than material.

> *It's an experience. Like when you burst the grape in your mouth. Pow!*
> THAT *moment. Art is happening in that moment. I feel it happening . . .*

11

there's some electricity. That moment when the painter reaches for that lit-tle bit of paint and looks at me and makes a mark, that second in time, where something is happening.—Liz

It is just happening in that moment. It's never static, it never depends upon the work. I really like that. You just have to do it. It's a real process thing. There is no outcome.—Nancy

If, as these models suggest, art is something experiential and transitory, rather than material and lasting, the roles of artist and model become complicated. If art is an experiential moment, who creates or participates in that moment? What is the model's role in that moment or process of art?

THE MODEL AS OBJECT

A few models do describe themselves as objects, tools to be used by the artist in creating or doing art, much as I had imagined at the beginning of my research. Artists contract and pay life models to pose nude in a place, time, and manner suitable to the artist. Models do not contract artists. These are concrete facts. And it is within this framework that the model becomes an object in the studio: object of the artist's gaze, object upon which the artist's creation is based, object to be purchased.

We all are material objects, you know. A lot of people object to that ter-minology. But we are physical, and I am a physical object with the capac-ity to move. And they [artists] are interested in seeing how that movement occurs and what I am as an object.—Russell

Your body is available to use as an object. . . . You are a collection of body parts, a collection of bones, tendons, veins. . . . Models, I guess, want to be recognized as more than just body parts, which we are. We are people, obviously. But you're talking about what we're hired for and why we're on stage. It's basically to be a body, be a collection of body parts.—James

Admitting that a model *can* be an object does not mean that he or she *must* be an object. Models explain that, in some cases, their role in the studio is that of object—"being a bowl of fruit"—and sometimes it is not. The deter-minants of the model's role in the studio tend to be largely circumstantial. Often, being an object may be all that is required of a model in a particular studio session.

Sometimes I really am a bowl of fruit. But, each class . . . each situa-tion is so totally different. If it's a big class and I don't have contact with the students or haven't developed a rapport . . . I'm just a bowl of fruit.—Karen

Sometimes, you are just an object, like a still life. Some people are trying to reproduce what they are looking at, and it doesn't matter what they are looking at. They are trying to capture form, contour, content, and trying to depict, so it doesn't really matter if you are a pear or an apple.—Timothy

Many times they are just there to practice techniques, so they are not there to be inspired. A lot of times in classroom situations they are trying to deal with all these technical matters of handling their media and seeing correctly, and then responding to what they are seeing and becoming accurate in describing what they are seeing. That's all their concern is. A lot of times I don't see why they have human beings there naked. A lot of times it's immaterial whether there is a person there or not.—Jason

Jason's focus on classroom settings hints at the one circumstance that models most often cite as the determinant of whether or not they are objectified: the artist's skill level. Unskilled artists or student artists are seen as limited in their ability to move beyond using the model as an object. These novice artists are still preoccupied with the mastery of technique, not the production of art, in either its processual or tangible form. Though this can cause frustration, as it did for Jason, models are generally tolerant of this sort of work, seeing it as a necessary step in the artist's training.

When I say that I feel like a bowl of fruit, it's not so much that I feel like a bowl of fruit, so much as I might as well be a bowl of fruit. Because, [the artists are] not trying to tune into my personality. They are so worried about what they are doing, that it's not art. But that's part of learning to be an artist. So I sit there.—Nancy

Models rarely express a preference for working with novice artists, but they realize that all artists are novices at some point. As artists advance in their technique and skills, models are less likely to take the role of object.

Well, I think that good models inspire people, and that inspired artists don't look at the model as an object. [The model is] more than just the muscles, or the structure, or information. There's also a spirit, there's a human being in that body, and a good artist, an inspired artist, is letting that inform their art work, letting it influence, so that it's really not a one-way thing. It's not just the model, and it's not just the artist, if it's good work.—Natalie

Wherever they placed themselves on the continuum between actor and object, the models I spoke with did not subscribe to common feminist interpretations of objectification as demoralizing or degrading. Rather, they discussed their occasional use as objects in purely practical terms. All people are physical objects on some level, they explain, and sometimes that is just the most useful and expedient thing to be. This is neither good nor bad, uplifting nor demoralizing; it is simply practical.

There is, of course, a large body of literature concerning objectification and the power of what has become known as "the gaze." When a viewer looks at a work of art, "the gaze" refers to what she or he sees and whose values and interests that view represents. "The gaze" describes power. Often, "the gaze" describes the differing depictions of men and women in artwork. In *Women, Art, and Power*, Linda Nochlin explains this as "the ways in which representations of women in art are founded upon and serve to reproduce indisputably accepted assumptions held by society in general, artists in particular, and some artists more than others about men's power over, superiority to, difference from, and necessary control of women, assumptions which are manifested in the visual structures as well as the thematic choices of the pictures in question."[1]

Of course, the power structures in any given society dictate where we are allowed to look and what is made available for us to look at. During the time of Jim Crow in the American South, for example, a black man could be lynched for "reckless eyeballing": looking at a white woman in what was deemed an inappropriate manner. More recently, some work and school sexual harassment policies have been fashioned to include suggestive looks or unwanted leering.[2] In the life studio, the model can become the object of the artist's gaze and then again be objectified by all those who might at a later time view the artist's work. According to some feminist theory, the fact that life models may not be consciously aware of their objectification does not mean that they are not, in fact, objectified; in her classic analysis of "visual pleasure" and the gaze, Laura Mulvey argues that the unconscious is formed by the dominant order so that what feels "natural" or "normal" to us is, in fact, socially conditioned and reflective of dominant power structures.[3] Of course, it is incorrect to assume a male artist and female model gender pattern always exists in the studio. Moreover, those doing the objectification may not be aware of their own influence. John Berger argues: "Men look at women. Women watch themselves being looked at. This determines not only most relations between men and women, but also the relations of women to themselves. The surveyor of woman in herself is male: the surveyed female. Thus she turns herself into an object—and most particularly an object of vision: a sight."[4] At an extreme, this theoretical stance can argue that all women, at all times, regardless of what they think or do, are objectified as long as social inequality exists between men and women.

At the very least, the life models I spoke with present a significant challenge to such views. First, they describe themselves in much more active and powerful terms: they control when and where they are objects, and they are consciously aware of their role. They are quick to point out that choosing to act as an object is not the same thing as choosing to be passive. Despite being immobile, and being watched, they refer to their work in active terms, often using the word *performance* to describe what they do while being an object.

Second, there is no discernable difference in the ways female and male models discuss their roles. Both describe being objects or objectifying themselves simply as a tool they sometimes used in doing their jobs.

> You have to be very still or that is not a good thing, but you don't really want to be passive.—Patrick

> The first word that came to mind was, I'm an athlete. I'm a performer. . . . I may be physically still, but to me it seems like a very active part.—Eric

Descriptions like "athlete" and "performer" contradict art historians and theorists who have more typically used language implying the passivity of the model and the activity of the artist. France Borel describes the respective roles of models and artists in the following terms: "[T]he woman lounges and lingers, the artist conquers, lays down his marks."[5] It may actually be that Borel and other art historians have exaggerated models' passivity out of an unrecognized allegiance to traditional gender roles. Borel, for one, speaks of models almost exclusively as female, and artists, almost without exception, as male. Such false notions reflect unequal gender roles and sexual scripts. "In a world ordered by sexual imbalance," Laura Mulvey states, "pleasure in looking has been split between active/male and passive/female."[6]

THE MODEL AS AGENT

Only a minority of models describe their role as that of an object. More often, they refer to themselves as coproducers of art, no more objects than are the artists. Models are partners or collaborators in the process of artistic production.

> It feels like some kind of collaboration. I go and Mark [the artist] pays me—I don't pay him to paint—and yet, what he wants is collaboration. At what point does it become collaboration, and at what point are the paintings mine, as well as his?—Liz

> There's an unspoken dialogue, a sense of connection. We are collaborating and doing something together. They're not drawing an object, they're drawing a human. I'm an event, I'm a human event, not an object.—Stephen

> You think it's the artists painting? No. It's both of us. Absolutely. I feel like I really participate in the actual art work. I put my name on some of the sculptures.—Karen

As a collaborator, the model leaves the role of object-to-be-used and assumes the role of the artist's equal partner. If artists merely want to perfect their

technique, the model-as-object might suffice, but if artists want to create art, they have to accept models as their cocreators. Many life models told me that the artists they worked with often struggled with this negotiation.

> There is an attitude among some art students: "I'm the artist and you are my model." But really you are the one in control. They are a lot more unconscious about what is going on than you are. When you are good at it, you can educate the artists.—Connie

To the outside observer of the art studio, the model-as-object and the model-as-agent may be indistinguishable. The collaboration between models and artists is not explicitly planned or vocalized, and in either role models will spend most of their time frozen, in silent poses. Yet life models explain that both collaboration and art—in its processual, ephemeral form—are experiential things, felt by artist and model together. Life models most often describe their partnership with artists as an exchange of energy.

> We are creating an energy together that is very particularly of the moment.—Susan

> There's an energy. There's some kind of energy that goes between the artist and the model.—Stephen

> Let's say I'm the artist. I look at the model as a source of energy. And I want to experience that energy like a dance. The model takes a pose, and the force of that pose, the eloquence of that pose, sort of rushes towards me and becomes the energy that flows through me, and I explode on paper. The model and the artist are dealing with each other on an incredibly high plane, and no one is better than the other. It's like they need each other to complete the experience.—Joan

It is this exchange or sharing of energy between artist and model that elevates a session above the mere practice of technique to the actual production of art, and the ability to exchange energy becomes the mark of a superior artist.

> [They] pick up on my feelings, and they put that into their artwork. When I am an active participant with the piece of artwork, I think they come out with better pieces. I know all of that energy is going into the sculpture. It goes right into the artwork.—Karen

> Once they become an artist, they actually get an essence of the model, not necessarily what you look like. It's an intuitive sort of thing that an artist acquires over time. It's like any skill. You get better and better and better over time to where you actually start. . . . You can actually feel the model.—Rachel

An energy exchange elevates a modeling session to the stature of "art" because the exchange opens a window into the spirit or inner being of the life

model. Although the models I spoke with struggled to describe this dynamic, it is by no means a new conception or one confined to modern life models' experience. Auguste Rodin (1840–1917) once said, "[T]he forms and attitudes of human beings necessarily reveal the emotions of their soul. The body always expresses the spirit. . . . And for those who know how to see, nudity offers the richest significance."[7] Today, life models might not agree that the body "necessarily" reveals the emotions of the soul, but they would agree that it can. They would explain that whether or not such revelation occurs depends upon the model's own decision making, skill, and effort, and they believe that if both model and artist are possessed of sufficient skill, an energy exchange will occur.

> They don't just want to draw the meat of your body, they want to draw your spirit. I can just be meat up on the podium, and be well-posed meat up on the podium, and it can be very useful; but I think after a point it can become extremely boring, because art and artists are ultimately going for something which is emotive, expressive . . . which is engaging on other levels, [not] just technical.—Liz

> You can bind up energy, or you can let the energy flow out. And when you let the energy flow out, there is this leap that is created. It is an electrical sort of deal that happens, and there is energy flowing in space, and you are going to feel people being inspired.—Susan

It is one thing to assert that an exchange of energy takes place between artist and model or that the production of art requires the infusion of the model's spirit, but it is another thing entirely to explain how this happens. Spiritual connections and energy exchanges are invisible to third-party observers. And while models agree that an exchange of energy occurs, most are unable to describe exactly how they go about emitting or receiving energy. In my interviews, when I pushed for clarification, models typically told me that the process was just too difficult for an outsider to understand and simply repeated their assertions that an energy exchange exists.

> It is hard to say, but I can just feel it, I guess. I can just feel my energy, so to speak. That kind of thing. It is hard to describe.—Patrick

> It flows through me. It moves from me out into the room. It moves toward the person that is working from me. And I want that to be expressed by the artist.—Joan

I began to get a clearer understanding of life models' use of energy when I asked about the particular medium of photography. Quite by accident, I learned that, to life models, photography is not the same as other artistic media and that the "energy exchange" is a key part of the difference.

THE PARTICULAR CASE OF PHOTOGRAPHY

Since life models care so much about establishing a flow of energy and think of art as a process, not a product, they are attuned to the different exigencies of working in different artistic media. Figure drawing, on the one hand, may involve a lot of "gestures" or quick poses, lasting between one and three minutes. Painting or sculpting, on the other hand, may require that the model hold a single pose for several hours, repeatedly over weeks or even months. Both situations have pros and cons from the model's perspective. A series of quick poses is relatively easy on the model's body and intellectually challenging, because she or he is constantly planning and assuming new poses. However, the quick pace and fragmented energy of a series of shorter poses often preclude the development of the artistic communion that models seek. According to models, this sense of collaboration and spiritual connection is more likely to develop in extended poses and sessions. Yet these longer poses are much more painful and demanding physically. In fact, a number of the models I met required medical attention for strained muscles and nerve damage following extended modeling jobs.

PHOTOGRAPHY AS ART

One medium stands out from all others in eliciting strong, usually negative opinions from life models: photography. French lithographer Nicephore Niepce invented photography in the early 1800s, an era dominated as never before by industrialism and positivist science.[8] From the beginning, it was the language of science as much as the language of art that was used to discuss this new medium.[9] By 1850, as the popularity of photography and the daguerreotype grew, fierce debate raged over whether or not photographs should be considered as art objects or cultural artifacts in their own right or whether it were not more accurate to discuss photography as a fantastically accurate "messenger."[10] The modernist aesthetic emphasized art's superiority to popular culture and high art's superiority to crafts and insisted upon originality in an ideology that Terry Barrett describes as a "reverence for the precious, unique art object."[11] Photography was devalued by some because of its technology-driven, reproducible nature.

Despite the rise of postmodernism in the twentieth century, and the postmodernist rejection of art as new or individualistic, the values of modernism lingered in the wider culture, and an emphasis on the "original, unique and unrepeatable" continued to plague photographic artists.[12] Two seminal midcentury works on the development of photography—Beaumont Newhall's *History of Photography* (1937), and Helmut Gernsheim's *Concise History of Photography* published in 1969—went so far as to deny photography the status of art.[13] Today major art publications such as *Artforum* and *Art in America* include photography, but as recently as June 1, 1999, the Photo-

graphic Society of America published a piece in its *PSA Journal* by Glen Val-
lance titled "Photography as Art? Yes!"[14] Susan Sontag's award winning book
On Photography states unequivocally that "photography is not an art like, say,
painting and poetry."[15] And some critics and theoreticians continue to debate
what sorts of photography constitute art. A recent issue of *The British Journal
of Photography*, for example, raised the question of whether or not nude cal-
endars commissioned by Ready Mix Concrete or Pirelli should "count" as
art.[16] And many schools seem equally unsure of the exact place of photogra-
phy; my own locates photography courses inside both the art department and
the department of media studies.

Because it is reproducible and dependent upon mechanical technology,
photography still holds only a fraction of the cultural capital of other artistic
media.[17] Thus, as Lynda Nead explains, one is a "consumer" of photographic
art, rather than a "connoisseur" of high art.[18] And Charles Desmarais, former
director of the California Museum of Photography in Riverside, mused, "I'm
not sure why it is that when you call yourself a photographer you charge
$300.00 for a picture, but if you're an artist it's ok to ask $30,000.00."[19] While
relatively few people may have tried figure sculpting or figure painting, most
of us have taken photographs of other people. As camera equipment has
become less expensive, even disposable, photography has become the artistic
medium of the masses. Amateur photographers do not need to have their
own darkrooms in order to develop and print their photographs. Today this
work can be completely mechanized, and for the amateur, done in under an
hour while he or she shops for groceries, or at home on an ink-jet printer. Of
course, there is a substantial difference between Herb Ritts's photography and
the average family's snapshots in terms of quality. Photography as a medium,
nevertheless, does not retain the high cultural capital of a scarce resource.

The denigration of photography as an artistic medium is evident in life
models' thinking about and perceptions of working for photographers. Most
of the work for which life models sit is realistic work—the model would be
easily recognizable in the finished piece. Yet this same realism or literalness
in a photograph is problematic for models. Very few life models told me that
they had been or would be willing to model for a photographer, and they
explained their aversion in terms of the reproducibility of photographs, a per-
ceived association with pornography, and the speed of photography.

THE TROUBLE WITH PHOTOGRAPHY

Original artwork is surrounded by what John Berger, for one, has described as
an "atmosphere of entirely bogus religiosity."[20] By this, Berger means that
works of art are "discussed and presented as though they were holy relics."[21]
A photograph, however, is accessible in a way that lowers its cultural capital.
From a life model's standpoint, the accessibility of photography—in the form

of reproducible celluloid negatives—is particularly troubling. Negatives mean that the model cannot know how many copies of his or her image will be made or where they will go. The proliferation of digital photography has only exacerbated this concern. They worry that digital images and negatives will take on lives of their own, perhaps eventually overshadowing or even damaging the model's own identity.

> I don't like the idea of negatives being in these people's hands. I think that a painting of me can't really be reproduced. Negatives you could take and reproduce, send them out, and. . . .—Leah

> [Photography is] too exposed, and it's too permanent, and you have no control over its use. Who knows where it's going to be even ten years from now or twenty years from now.—Donald

Life models retain no legal control over any of the images produced in a session, regardless of medium. Most of the models I talked with had no idea what had become of the paintings, drawings, or sculptures made during their sessions or the eventual whereabouts of their image. Yet this did not provoke the life model's concern in the way that photography did.

The reproducibility of photographs, while problematic in its own right, is further complicated by nude photography's association with pornography. Because photography as an artistic medium is widely held in less regard than such media as painting or sculpting, photographers, too, are considered somewhat suspect as artists—especially if their subject matter involves nudity. The now infamous struggles of photographer Robert Maplethorpe and the National Endowment for the Arts did a great deal to establish this link between nude photography and obscenity in our broader cultural consciousness. In 1991, for the first time in U.S. history, an art museum and art museum director were criminally prosecuted under obscenity laws for showing a series of Maplethorpe's photographs including homoerotic imagery.[22] These same photographs became the lightening rod for attacks, spearheaded by North Carolina Senator Jesse Helms, on the National Endowment for the Arts, Maplethorpe's source of funding. Later, Professor Nadine Strossen, president of the American Civil Liberties Union, would argue that "the sustained attack on sexual content in works for which artists are seeking NEA grants has had a spillover effect far beyond the government funding context."[23] At the University of Arizona, Tucson, for example, students attacked an exhibit of self-portrait photographs by a fellow student, Laurie Blakeslee, because she had photographed herself in her underwear.[24] And, in 1993, according to the *Washington Times*, photographer and fine arts professor Don Evans was charged with sexual harassment and sanctioned by Vanderbilt University for including displays and discussions of sexually explicit photographs, both his own and those of Robert Maplethorpe, in his course on photography and design.[25]

Today, many artists and supporters of the arts have become fearful of any art that might be interpreted sexually, and this fear is particularly pervasive within the visual arts. The state of Oregon, home to the life models I studied, is one of only a few states that have invalidated obscenity laws under free speech guarantees in its state constitution.[26] Even so, fears of reprisal are not entirely unfounded. In the minds of many, any photograph of a nude is suspect. In a roundtable for MS Magazine, antipornography feminist Andrea Dworkin explained that for her, "it's very hard to look at a picture of a woman's body and not see it with the perception that her body is being exploited."[27] For the life models I interviewed, nude photographs were not inherently pornographic, but models did worry that the negatives from an artistic photography sitting might be used pornographically. Male and female models shared this concern, although women were more likely to express it as soon as I mentioned modeling for photography.

> Lots of models are very protective about having their photographs taken because of the pornography. . . . They don't want it to be used as erotica or pornography.—Tracey

The growth of the internet has intensified life models' distrust of photography. Many expressed anxiety that their images might be digitally altered and distributed worldwide over the Internet. It did not seem to be the distribution of the images that was troubling so much as the idea that the images might be used pornographically and even altered to heighten their potential sexual use. In particular, models were concerned that parts of their bodies such as breasts and penises might be digitally and unnaturally enhanced. If such an enhancement occurred in the process of creating an original artwork, it did not trouble the models, but if it were done by a third party, after the art was completed and only for the purpose of sexual stimulation, it was not acceptable. This concern about cyber-porn was particularly interesting given that, at the time of our interviews, most models I met had limited, if any, access to the World Wide Web or Internet. Their perception of the sale and distribution of sexual materials over the Internet, a huge and largely unregulated industry, mostly came from sources other than direct experience with the Internet. No models told me that they had actually found such images of themselves on the Internet, and no one reported knowing any other life model who had.

In addition to concerns about reproducibility and the association with pornography, models also expressed dissatisfaction with the speed of photographic work. A photographer may invest many hours in conceptualizing and planning a particular shoot and many more in developing and printing the results, but the time required to capture an image is quite brief when compared to the painstaking processes of painting and sculpting.

The poses are real quick. I mean, you've only got the shutter speed to worry about, so, it's different.—Michael

While a painter may work for hours and still have only the roughest outline of a figure completed, a photographer, in a matter of seconds, has a completed image. Although she may take other photos, the traditional photographer cannot "go back" or continue to work on an image once the shutter has closed. Of course, digital photography and editing programs, such as Photoshop, are making it possible for a photographer to work on an image long after the shutter has closed. Nevertheless, when I was conducting my research, little "artistic" photography was done with digital equipment, and digital enhancement was considered unacceptable in traditional, "artistic photography" circles. It remains to be seen whether new technologies allowing photo manipulation will further denigrate photography's rank in the artistic hierarchy or will instead raise the status of photography as the line between painting and photography is blurred.

The most obvious problem with the speed of photography for models was the limit it put on their wages. Life models are paid by the hour, and for most media, sessions are rarely shorter than three hours, meaning that a typical Portland model, earning ten dollars an hour, would make around thirty dollars per session. Given that models must travel to and from the studio and allow time for preparation, sessions shorter than three hours become financially impractical, unless the model is paid more for a shorter period of time.

I expect to be compensated. I'd expect to be paid much more than I did modeling for artists. Photographs take seconds to be produced, and a drawing of me that would be that detailed and that literal would take hours and hours and hours, and I would be paid for those hours and hours and hours.—Liz

Although a three-hour figure drawing session might result in multiple depictions of the model, these works are usually practice pieces through which an artist perfects technique; they are not finished products. Quick sketches, paintings, or sculptures of gestures are rarely even kept by the artist. A photographer, in contrast, can have multiple, different, and complete works from a single session, and though she or he might discard some, other images might be deemed worthy of reproduction many times. For this reason, there is a feeling among some models that if and when they do choose to pose for photography, they should be paid not only by the hour but also on a picture-by-picture basis.

Life models do distinguish between posing for reference photos and posing for photographs that are intended as art. They are more sympathetic to reference photos. A reference photograph is taken of the model while in position and used by the artist to continue work on his sculpture or painting in

the absence of the life model. Reference photos are not taken by photographers, and they are not intended as an art form in themselves but are a means to another end. Presumably, when the work is complete, the reference photos are destroyed, being of no inherent value themselves. In reality, of course, many of these photos are saved, and museums can sometimes obtain photos of models posing for the great works in their collections.[28]

Reference photos are a touchy issue in the art studio, for both artists and models. Artists are rarely wealthy, and the cost of hiring a life model at ten dollars or more per hour may be beyond their means, particularly if the artists are engaged in works that may take months to complete. This creates a financial incentive for artists to use reference photos for at least some of their time. The culture of the studio and the edicts of most artists' training, however, serve as disincentives to the reference photo technique. Each reference photo that a model allows reduces his or her income proportionately and, some models argue, denigrates the importance of the presence of the life model to the artistic process. While most models I spoke with reported that they had allowed limited reference photos to be taken of their poses, a few models vehemently refused to pose for any photography, including reference photos.

> I don't allow photographs. I don't model for photography. I think that if people are going to paint from life they should paint from the model not from the photograph. It just doesn't look the same. Personally, I have almost never seen a good painting from a photograph, whether it was a human being or a still life or a landscape. A photograph just doesn't have enough information. . . . And, you know, a lot of people do that [take reference photos] because they are cheap. It's like, "Well, let me take a photograph of that" and it's like, "Well, no, pay me for the three hours."—Joan

Life models' dedication to the artistic process might be sufficient cause to overlook the low wages of photography if they did not also find it extremely difficult to experience art with a photographer. The brevity of photographic poses makes an energy exchange very difficult to establish.

> I don't think I relate to the camera as well. It's too different. You are not really involved. The process is really important to me—watching them [painters] go through the brushes, hearing the erasure, the flailing around of the students— it's a process that incorporates me. The camera is different. It's colder. It's more like a machine that I can't really relate very well to.—Joan

Our language reflects the passive role of the model in photography: a photographer is said to "take" a picture, while a painter, conversely, "makes" or "creates" a picture. "Taking" implies none of the model's participation—he or she is giving something up, not participating in a process. And, although models might tolerate being used as objects by painters and sculptors, they are not interested in being an object for a photographer. Because of the association with

pornography, they find the experience too close to being a sex object. Their characterizations of photographers often reflect their distrust of photographers' motives: they describe the work being done as "easy," "cheap," and "shallow."

> They [photographers] have a whole different mentality about art. They are quick and easy. They are superficial. They don't put their own energy into it, as much as they capture mine. They pick that medium because they are coming from a faster, more technical, more shallow mentality. They don't put as much of themselves and their creativity and their emotional expression into the artwork. Not much goes into a photograph, but a lot goes into a painting.—Karen

> I admire photography a lot, and like I said, I'm a filmmaker myself, but I just think it seems like some kind of cheaper transmission. It's just so easy to take a picture of somebody, for the artist. I mean, technically, you have to know the f-stop, but if you have a good eye, you can take pictures pretty easy, and not spend hours and hours working on something.—Leah

It is not unusual for models to ascribe sensual characteristics to paints, brushes, or clay. Cameras, lenses, and film, on the other hand, are described as mechanistic, and this lack of sensuality inhibits an energy exchange between the artist and models.

> Well, that [modeling for photography] to me is the least satisfying actually because it seems the most removed from this rapport that develops between the model and the artist, or the photographer in this case. It seems the camera with its mechanical. . . . It is a cold kind of calculating instrument that is between you and the person behind the camera.—Jason

It may be the models' inability to establish a flow of energy with the photographer that explains, in part, why models object to the electronic distribution of their photographic image but not to the similar distribution of their painted or sculpted image. Say, for example, that a model has posed for a sculptor and that later an image of the resultant piece was distributed over the Internet. In this case, the art that happened occurred between the model and the sculptor. The person who takes the picture of the finished sculpture is not an artist and is not participating in an artistic process, she is simply taking a picture of the by-product of the earlier art. While the model may be perfectly recognizable in the sculpture and may not appreciate the digitization and distribution of her likeness, that likeness has been cleansed through its birth in the artistic process. A photography session, on the contrary, is unlikely to reach the status of art, due to the difficulty of establishing an exchange of energy between photographer and model. Thus, when a photographer reproduces or distributes his work, that work is not a by-product of art and so is unclean.

In On Photography, Susan Sontag notes that, to most of us, photographic images "do not seem to be statements about the world so much as pieces of it,

miniatures of reality that anyone can make or acquire."[29] To lay people, photography seems to capture a "reality" or "truth" more literal than the interpretive representations of sculpture or painting. Many photographers and theorists, however, have rejected this perception. Joel Snyder and Neil Walsh Allen, for example, joke that: "A photograph shows us what we 'would have seen' at a certain moment in time, *from* a certain vantage point *if* we kept our head immobile *and* closed one eye *and if* we saw things in Agfacolor or in Tri-X developed in D-76 and printed on Kodabromide #3 paper."[30] The life models I spoke with, however, were not familiar with such theoretical claims and almost universally considered photographs to be more exact, more accurate, or more literal depictions than those rendered by other artistic media.

> *It's you up there, recognizable. It's not an artist's interpretation of you. It's a document.*—Susan

Models do not have the same fear of recognition when posing for painters or sculptors, no matter how "realistic" or identifiable the model might be in the final product. The models I interviewed acknowledged these inconsistencies in their thinking and struggled to make sense of them for me.

> *Most artists I have seen are very good. They can reproduce my features very well. I mean, you look at it and go, "Yeah, that's me, that's my face." It pretty well matches. So, as far as accuracy, they can do that. But for some reason, with a drawing I feel that it is somebody's interpretation of me. It is not really me. When I look at a photograph, I think, "That's me." That is me. . . . I feel less comfortable with that. . . . I wouldn't feel at all uncomfortable with somebody having a painting of me on their wall from a modeling session. But a photograph, for some reason, I would.*—Patrick

Theoretically, through the notion of art as something ephemeral or processual, such inconsistencies are less difficult to understand. In this conception, art is something interactional, something done by both artist and model, and the painting or sculpture is the tangible remainder or by-product that is left to signify that interaction. If the nude model is recognizable in that remainder, his or her nudity has already been legitimated or cleansed via involvement in art. With photography, however, the interaction required to produce art does not typically take place. A recognizable nude model in a photograph is simply naked. His or her nudity has not been legitimated by the process of art. Models feel the accuracy or literalness of a photograph to be an invasion of their privacy, while similarly accurate paintings are not.[31] In the words of John Berger: "To be naked is to be oneself. To be nude is to be seen naked by others and yet not recognized for oneself."[32] So, in Berger's terms, a life model's depiction in a photograph is that of a naked man or woman, while that same depiction in paint or clay would be of a nude.

THREE

"Stephen"

MODELS OFTEN TOLD ME that they didn't know any other life models in the Portland area and that they rarely got to see other models at work. Yet model after model told me that if I wanted to understand life modeling in Portland, I should talk with Stephen. Even if they had not personally met Stephen, they spoke as if they knew him and had some story to tell about him. Stephen was known for the acrobatics of his poses, such as holding a pose while standing on his head. I was told that he was the only model in the Portland area who was able to work full time as a life model. Although almost all of the models I interviewed had heard of Stephen, none could offer me a phone number or address for him. So for four months, while conducting interviews, I tried to put together bits and pieces of gossip about him.

Stephen had no telephone number because he had no telephone. He took calls at a local bar. Most accounts also mentioned that one or two local female models were his lovers. Jane, the woman who was mentioned most often in connection with Stephen, was included in a list of models' names I had obtained from an art school, but I had not yet interviewed her. Word had it that Jane was married to somebody other than Stephen. While I didn't relish the idea of questioning anybody about an extramarital affair, I did want to meet Stephen, and Jane seemed my best conduit. I scheduled an interview with her hoping that during the course of our conversation the subject of Stephen would come up and that I would be able to exploit the opening. In fact, when we met, we did discuss Stephen, but they had recently broken up, and Jane was not about to help me find him.

I finally met Stephen at a local college. A research assistant, one of three undergraduate students who worked with me over the course of my research, was helping me present some of our early interviews at a symposium on gender studies. We were seated along with other presenters at a long table at the front of a modest-sized auditorium. While speaking, I stood at a podium, my

research assistant seated to my right. We had just concluded our formal pre-
sentation and asked for questions from the audience, when a tall, muscular
man, apparently in his early sixties, with a shaved head and wearing a full set
of leathers—boots, pants, vest, jacket, and gloves—leapt from his seat and
came toward the podium. Holding a motorcycle helmet, he shouted, "*I am a
life model! I want to talk to you! Do I ever get to talk to you?*" Not accustomed
to would-be research subjects demanding interviews, or to members of acad-
emic audiences storming the stage, I told him that I would take his phone
number and call him. But he was obviously anxious to have his say right away
and seemed only partially pacified by my offer. I didn't know if he was actu-
ally a model, or instead an unbalanced person who had wandered in on this
free event. I scanned the room for another question from the audience. As I
turned to my right, I happened to glance down at my research assistant, and
saw that on her paper she'd written in bold letters: "STEPHEN!"

Stephen is among the most charismatic people I have ever interviewed.
Arriving for our interview on a Harley-Davidson, despite the Portland rain,
and dressed once again in full leathers, he did not try to present himself as
particularly educated or knowledgeable but had a disarming openness about
his own thoughts and experiences. I could easily understand why he was a
sought-after model. In his sixties, his body was still what life models called
"the Greek statue type." He was obviously proud of it. I learned that his
behavior weeks earlier was not anomalous: everything about Stephen was
colorful, including his introduction to life modeling.

> The first time I modeled was for an artist who was the father of my best
> friend in childhood. I had just finished hitchhiking across the country and
> taking a lot of psychoactive substances in the middle 1960s, and I had
> decided that I was going to be a sculptor. And while I was there with my
> beads and my long hair, the father said, "You know, I'd really like to try to
> draw a portrait of you." This was a man who came to this country from
> Latvia and made his living in New York during the Depression by going to
> restaurants, finding a napkin, and drawing a charcoal portrait of a waitress.

Through interviews with other models, I had learned that this sort of
"accidental" beginning to life modeling was not unusual. People were often
introduced to life modeling through family or friends who were already
involved in the artistic community. I asked Stephen when he consciously
made the decision to pursue modeling as a profession.

> I became an art model in 1980, by default. I'd been spending a couple of
> years living in a cabin in Minnesota, trying to find myself by being alone.
> I hitchhiked into Duluth to see some friends in a play. During the play,
> there was a fire alarm, so we all had to leave the theater. I went out to the
> foyer, where everyone was standing around, and I saw an old friend who

told me she was working in the ceramics department there. We had a little chat, you know, renewing our acquaintance, and she said, "My friend here," gesturing to a woman dressed in a robe and standing next to her, "Eileen, can't model anymore, because she's a student and the school won't let her model if she's a student." I said, "Jeez, I just came to Duluth today, and I'm looking for work. I don't have any place, and I don't have any money, and I don't have any work, and I'd like to do that. I like art." So the next thing I did was to start modeling for art classes at the University of Wisconsin, Superior, and the University of Minnesota, Duluth. I worked there for about a term and a half before my sense of my direction called me away from there.

Like Stephen, most life models I interviewed described their introduction to life modeling and the beginning of their careers as something that happened to them, the work of chance, rather than as something they actually sought out. If models did not actively pursue their profession, I wondered how they knew what to do when they arrived at a studio for their very first job. When I asked Stephen how he had known what to do the first time he posed, he explained that most of his training had been outside of the studio, in other aspects of his life:

I'd done some yoga and some modern dance, and I'd been a wrestler in high school, too, so I knew something about where my feet and my hands were in relation to everything else, and where my balance was. I had a sense of being in my body, and using my body to move through space. So, I hadn't been a model before, I just seemed to have a talent for it.

Life modeling is usually a part-time, sporadic occupation. Even a city known for its dedication to figurative art, such as Portland, rarely has full-time work for models. Moreover, the physical demands of the job make it impossible for most models to work regular eight-hour days. Since Stephen had come to life modeling older than most, and worked longer than most, I wondered how regularly he had been working since his first experience modeling for his father's friend. He told me that modeling had, at first, been a short-lived career for him. He had moved on to pursue other work. He returned to life modeling much later as part of what he described as a midlife crisis.

I shaved my head and changed my name. Then someone came up to me and said, "Gee, I'd really love to draw your head. You should try being an art model." And I said, "Oh, well, I used to do that long ago—I think I'll try that." Right away people started raving about me, really loving what I brought to art.

He began to get so much work that he was able to make life modeling his only paid work.

Part of what Stephen "brought to art" was a level of acrobatics in his pos-ing that made him exceptional among local life models. I wondered why he would go to such often-painful extremes when, given his body type, classic contrapposto poses would satisfy most artists and be much more comfortable for him. It became clear that the poses Stephen took were less about provid-ing an interesting view for the artists than they were about providing an avenue of self-expression for Stephen.

> This was an opportunity for me to act, to perform. . . . I'd done all this mechanical-y stuff, where I had to know how to do stuff with machinery. I'd been a carpenter, an auto mechanic, a welder, and a merchant sea-man. . . . Modeling was different, and I felt that it was an art form for me, which allowed me to convey something about who I am as a human being. Modeling, I could be fully self-expressed without saying anything, without knowing how to fix anything.

It was difficult to imagine this active, voluble man sitting still and silent, much less feeling satisfied expressing himself in a single static position. While we had been talking, Stephen had been almost aggressive in his desire to be understood, talking animatedly and at length. Yet I knew that he had a rep-utation as an exceptionally talented life model, and I knew the importance of being able to hold a pose and keep silent for hours at a time to that reputa-tion. Stephen realized he was an excellent model. Unlike many models I spoke with, he expressed no surprise that artists liked working from his body, and he did not use modeling to improve a lagging self-esteem about his phys-ical appearance. He believed his bold spirit and sense of adventure brought something special to a modeling session.

> I come with enthusiasm, and I embody that enthusiasm. I try to find my limits and sometimes exceed my limits. Sometimes I take poses that are difficult. In fact, often I take poses that other people don't do, like stand-ing on my hands, or poses where my arms are way over my head, grab-bing something that I can barely hold on to. I'm trying to provide a sense of dynamic tension, some real activity going on, some intention going on. It's not always confined to the physical realm.

Like many life models, Stephen stressed the centrality of mental processes to his poses. Often the mental or emotional components of a ses-sion, rather than the physical aspects, make a pose or session good or bad for the life model. Although many models told me about the mental exercises they performed while modeling, Stephen had a unique way of describing his:

> One of my favorite things to do is to imagine that I'm seeing my best friend walk through the other wall of the studio, someone that I haven't seen for a long time, like a guardian angel. And well, it's like being thirsty and there's

that drink of water for the soul. I will hold that thought, and what happens then is that my whole being responds to that sense of, "I've been waiting for this. I'm so glad." And so sometimes I just try to show being glad—really, really excited about living and feeling very happy and complete. Just on the edge, just reaching what I want to be, where I want to be.

Stephen expressed an exceptional passion for modeling. During our first interview he kept jumping forward in his seat and then sitting back again, as if he had to keep reminding himself to remain seated. We were meeting in a coffee shop, as I always did for first interviews with models; understandably, models are wary of meeting strangers outside of art studios, so I tried to pick a public place near a model's home or work until she or he felt confident that I really was a researcher and not an imposter hoping to act out some sexual fantasy with a nude model. Despite sitting in a public cafe, though, Stephen spoke loudly and intently, oblivious to the eavesdroppers who had gradually accumulated at nearby tables. Although they tried, at first, to focus on their coffee drinks, after a while most of our neighbors were openly listening to our conversation. I asked what it was about life modeling that made it so important to Stephen. He explained that modeling was, for him, a "devotional" act.

I can witness the spirit in my body and the way that it is manifest. It's like, I'm energy, and I'm on a spiritual path. Being stripped to the bone, I am being continually. Who I think I am gets torn off of me, and I have to see myself in a new way, a way that isn't who I think I am or who I think I want to be. I'm on a path.

I told Stephen that I was surprised to hear this sort of an explanation from a man, since in my experience, it was usually women models who described their modeling work in spiritual terms. He understood my surprise and unselfconsciously explained that he was not a mainstream male.

When I was a kid, I really didn't want to be a man, but I knew I was going to be one, and I decided I was going to find my own definition of what is a man. Most of the men that I knew seemed really unhappy, really tormented beings. Men weren't supposed to have emotions and were supposed to just do things that they hated that made a lot of money. And I chose to redefine being a man.

Uncomfortable with what he described as "status-quo" values for men, Stephen sought an avenue for change. Through modeling, Stephen was able to work toward becoming his own definition of a man.

I want to be a man who is strong, who is male, who is so strong that he can afford to be gentle, that he can realize in his strength that he doesn't have to be fearful and closed. That's what I'm working towards in my life.

So I might be the one male model who you talk to who says that I see mod-
eling as a part of my spiritual path. Modeling is a way of expressing deep,
subtle things about myself in a nonverbal way.

As is often the case with long-term models, life modeling had become an
integral part of a journey of self-exploration for Stephen. Unlike other mod-
els, Stephen was eager to talk about this journey. A turning point for him
came when a woman he loved rebuffed his proposal of marriage. For a while
he considered suicide, then he decided instead, to destroy a collection of art-
work he himself had made—large "car-body sculptures," ornamental iron-
work, and jewelry. After that, he felt that the "best part" of himself was dead,
until he rediscovered modeling.

It wasn't until I started art modeling that I found that there was this
residue, this little crust of burned remains of desire to be engaged in a
process of art.

Stephen had incorporated painful periods in his life into his persona as a
lone wolf, a renegade, a powerful man sheltering a tender heart. He was sur-
prisingly up-front about the constructedness of his self-image and his con-
comitant self-absorption. He believed that focusing on himself had made him
a better person.

You know, I've really been a narcissist and examined myself a great deal.
What that's led to, though, is transcendence. I've kind of gone around the
block with myself . . . I've explored hard.

Stephen may have found personal success in life modeling, but that had
not translated into financial success. Despite being a sought-after model, he
still found it difficult to make ends meet. Even working more than many
models in the area, he still could barely pay his rent, buy food, and meet his
other financial obligations. Stephen admitted that this made his life difficult
and, at times, thin. He was grateful that he was able to live indoors and felt
that shelter was not something he could take for granted. He was unwilling
to consider returning to more steady, remunerative work, because he believed
that in some spiritual or cosmic sense, life modeling was what he was sup-
posed to do.

Art modeling is natural for me, and I found out that people really love me,
and then I found out, boy I really love this, that I really feel like I'm show-
ing up. It's like acting, dancing, playing . . . joyful activity. Yoga, tai chi,
dance, you know, those kinds of things, that's what I'm supposed to do.
And I'm supposed to do that, not just as an animal, but I'm supposed to
do that as a conscious entity. Art modeling is, for me, a chosen action,
coming from me having a life I want to have, showing up in a way that I
feel really adds to harmony, and beauty, and joy.

Many models are thoughtful and articulate about their work. Many have strong opinions about their role in artistic production and about the sensual aspects of their work. Stephen was unlike most in that he had no other "regular" job and in that he had dedicated himself full time to a journey of self-exploration and understanding that was integrally tied to his work.

The last time I met with Stephen, I asked him if he had any questions for me. He asked me what I did. I told him I was a college professor in the Department of Sociology, something I had of course explained to him before our first meeting, but which he had temporarily forgotten. He thought about my job for a few minutes. Then, as if in sympathy, he told me,

You know, I went to college to become a sociologist, but was only there for a few quarters before I decided to just kind of bike around the country.

FOUR

Defining the Line

Sexual Work versus Sex Work

COOPERATIVE INTERACTION IN THE ART STUDIO

TO WORK AS A NUDE MODEL is to invite public scorn and disapproval. And like others who engage in behavior that is devalued or degraded, life models attempt to gain legitimacy for their work by claiming that posing is done for the attainment of a higher, more valued end.[1] In other words, what would normally be an illegitimate activity (in this case, being naked, among strangers, in a semipublic setting) can be legitimated through the claim that the activity is necessary to the pursuit of a higher goal (in this case, art). Thus, prostitutes argue that they are offering a needed social service by providing an outlet for sexual desire, which would otherwise be channeled into even less acceptable avenues such as rape or molestation; strippers make similar claims.[2] In the opinion of the life models I spoke with, not only does the artistic requirement of working from life legitimate their nakedness, but the goal of artistic creation elevates the occupation of life modeling above many, if not most, other professions. The pursuit of art is considered higher than other more obviously commercial pursuits. Comparing life modeling to other forms of employment, life models describe their work as more pure, honest, and enlightened.

> *I feel like it's an enlightened thing to do. In a way, I feel like the human form is the basis for art. Or it's the thing that we, as humans, respond most strongly to, and so it is kind of what art hinges on. It's universal. I feel like there are few really high things that people can do without destroying . . . where they are just elevating themselves.*—Nancy

> *The love of beauty . . . purifying the world. That's one of the highest callings that I can think of.*—Stephen

35

Few of us would argue with the legitimacy of artistic endeavor. We admire artists, and, although we may not consider becoming an artist a financially savvy move, we do consider it an interesting and romantic choice. Clearly, we are not willing to transfer this same legitimacy to nude modeling. If we were, life modeling would be an accepted profession, one that parents encouraged their children to explore, much as they might encourage children to explore and develop their artistic talents. But this is not the case and never has been. Instead, life models find themselves burdened with the vindication of their profession. At the very least, they must neutralize their own feelings of guilt or deviance, which, left unchecked, would prevent them from continuing their work. Claiming the pursuit of a higher end—art—makes it possible for life models to work without seeing themselves as immoral or deviant.[3]

Once models have convinced themselves of their worth, they must also convey that sense of legitimacy to the other participants in the art studio. Yet there are rarely written contracts that define the model's role in the production of art or the artist's relationship to the model. What's more, most of the model's time in the studio is spent posing, immobile and silent. This means that the conveyance of the model's legitimated definition of the situation must occur subtly and nonverbally. Somehow, life models must convince everybody else involved in the studio that what they do is legitimate work, and they must do this without talking.

This sort of complicated dance of interaction where all actors in the studio come to agree upon a definition of life modeling as legitimate work is not unique to the art studio. We all engage in interactive negotiations every day. For example, if I am walking on the sidewalk, and a stranger is walking toward me on the same sidewalk, it is unlikely that we will collide. It is equally unlikely that we will both stop and discuss how to handle our approaching impact or even give it any self-conscious thought. Instead, through a subtle interaction of eye and body movements, we will both "agree" to move far enough to the side to avoid physical contact. Most of the time we go about these interaction rituals in a taken-for-granted way.[4] The unconscious way in which we participate in these interactions makes the subtle negotiation process difficult for an observer to see. Such processes of cooperative interaction can be made visible most easily in situations where actors are performing roles that might be considered socially unacceptable. For example, an adult woman would not normally take off her clothes and sit naked before a man she does not know. Nor would she normally let this man touch her body or order her to move her body this way and that. But if she is a patient, and the male is her doctor, she will. At no time prior to the exam do the doctor and patient sit down and explicitly state that what they are about to do is problematic. Rather, they try through interactional cooperation to make an abnormal situation as normal as possible.[5]

Life models are very aware of their "performance," and they speak thoughtfully about the shifting definitions and interactional transitions in their work.[6] Perhaps their heightened awareness comes from the fact that their work is stigmatized; those who experience oppression, discrimination, or stigmatization often have a heightened awareness of "taken for granted" behaviors. For life models, their choice to pursue a profession that generally elicits more scorn than appreciation forces them consciously to consider their role in the studio setting. They have to answer the question, How could you do such a thing? much more often than painters or sculptors do, though they may share the same studio and many of the same goals.

SEPARATING SEXUAL WORK FROM SEX WORK

Life models' interactions in the studio are centered on a single goal: defining and maintaining the definition of the studio situation as legitimate and professional. Among their first concerns is the general population's misperception of their work as sex work. In the minds of many people, artistic inspiration seems linked to sexual arousal, and the life model as muse seems to be a font of that sexual inspiration. In addition, the physical processes of sculpting and painting—molding clay and applying paint to canvas—have been charged with sexual connotations. We describe these processes in sexualized terms: light is said to "caress" form, shapes to become "voluptuous"; color is described as "sensuous," paint as "luxurious."[7] In this context, the life model appears to offer titillation. Further, because life models have historically harkened from the same social ranks as prostitutes, their sexuality is viewed as dangerous, risky, naughty.

The bohemian image of artists has compounded notions of modeling as sexually charged.[8] Today, Hollywood tends to portray "great" artists as unkempt, socially awkward, emotionally tormented men living in huge studio-lofts in New York City; there are few stories about tidy, socially graceful, serious, female artists living in the suburbs. Popular perceptions of artistic lifestyles as outside the boundaries of mainstream society further ensure that anyone involved with artists, either socially or sexually, risks sharing their liminal status.

LIFE MODELING AS SEXUAL WORK

Despite pervasive images of models as temptresses and seductresses, contemporary life models deny that their work is overtly sexual. Many assured me that they do not engage artists in sexual intercourse, foreplay, or flirtation. They considered any suggestion that modeling might involve sex not only disrespectful, but also hopelessly pedestrian. According to them, only unenlightened thinkers would confuse the naked (sexual) with the nude (nonsexual).

They agree that there is a sexual *element* to their work but insist that it bears little resemblance to the titillating fantasies of popular culture.

Many models label their work "sensual" rather than "sexual."

> *I think there is a very subtle sexual element that is inherent in modeling. Rather than sexual, I like to think of it as sensual. I like to use that sensuality in my poses to really be expressive of the moment, of who I am, and of how I am feeling.—Joan*

> *I see a difference between beauty and a sexual kind of feel. They can be the same thing at some point, but I don't see that they always have to be together at the same time. I guess in some way, I would describe this as sensual. There is certainly a feeling that you will get from different models.—Patrick*

The exact distinction between "sexual" and "sensual" is difficult for models to describe but appears to be rooted in the difference between the individual and the abstract. Sexuality as described by popular culture is the sexuality of the individual. It is personal, directed, and involves specific participants. In contrast, the sensuality described by life models is sexuality in the abstract, a part of what many models termed "human sexuality." This sensuality, or human sexuality, is not directed at any individual, nor is it aimed at a specific sexual encounter or release. Rather, it is the unavoidable sexuality of human beings as human beings, a species participating in reproductive processes. Sexuality of the individual involves free will and conscious decision making. Sexuality in the abstract is inevitable and outside of the control of the individual.

> *I believe my sexuality is in my body. To look at my body is to somehow come in contact with my sexuality. I think that to think that weren't true at all [would be] to be in a state of severe denial.—Liz*

> *Well, I think you would be stupid to deny it . . . the body is exciting to all of us. I think the artists try to capitalize on that in their art. You know, they try to show that sexuality in their artwork. If you didn't have that element of sexuality in it, it wouldn't be interesting to anybody. Artists try and get that, and I don't think it's bad at all. I mean, we're sexual beings, and I think that's part and parcel of it.—Michael*

Devoid of individual volition, this more abstract human sexuality is seen as cleaner, purer, more noble than individual sexuality. Human sexuality is sexuality without the lust of individual sexuality. In serving the exalted cause of art, human sexuality is further purified. If art is among our highest forms of cultural capital, then that which serves to improve art, in this case the model's sexuality, is also raised socially.[9]

Sexuality is definitely there for me, but it's brought to a level of . . . it's like a higher level. There's definitely sexuality there, but it's about human sexuality.—Tracey

For some models, this form of abstract human sexuality is so pervasive in all aspects of any individual's daily life that the artist's studio is not a unique setting. For these models, the studio is simply one more setting for the inevitable expression of human sexuality.

I mean, ultimately we are all on some level incredibly sexual, all of us. . . . So, I don't think there's necessarily more of a sexual text going on in life modeling than there is in daily life.—Russell

You can sexualize any moment . . . taking a shower, if that is sexual to you. Or when you go to the bathroom. . . . Or even when you change your clothes.—Susan

Perhaps because they are defining the sexuality of the studio as abstract human sexuality, models rarely make gender specifications when discussing the sexual element of modeling. All studio participants are seen as being a part of, and influenced by, this abstract sexuality, regardless of their sexual preferences or orientations. A nude model, either male or female, and the male or female artists in the studio will all participate in the performance of human sexuality.

While life models work hard to define the sexuality of the studio in clean, abstract terms, they also acknowledge that it is not unusual for the abstract sexuality of the studio to transform into more specific or individual sexuality. Without exception, they acknowledge that working from a life model can be sexually arousing for artists. Failing to acknowledge the potential for sexual arousal is seen as disingenuous on the part of an artist.

I know that it is always lurking at varying levels in their [artists] consciousness. A lot of them would never admit it. When they come here, they pretend that it is strictly technique and practice, but I know that they are coming here because this kind of occasion affords them a chance to question things in themselves and to get excited and to do it in a socially acceptable way.—Jason

Other people say it is not at all about sex, "I am just drawing, and you are strictly an object." So it's either all about sex or not at all about sex, devoid of any sexuality. Then why aren't they willing to say that it is devoid of any other emotion? They are seeing themselves as elevated, as exploring the sorrow and joy of humanity, but not the sexuality?—Connie

The artist's arousal is not problematic and, in fact, is seen as positive as long as it is used toward the production of art.

If somebody out there in the audience, as it were, finds me attractive and it helps them to do something that excites them artistically, and if somebody out there in the audience is turned on by me, and it's helping them do great art work, I'm really, really happy about it.—Tracey

I might be doing a pose where I'm sprawled out on my back, in kind of a contorted pose and my genitals may be, you know, one of the predominant features. The arms and legs are doing something, but also the genitals are right out there. For some people, drawing that may be really erotic. They may have a real erotic impression of it, and [it will show] in their artwork. It may seem really luscious and erotic. That's okay with me if they're doing that. I don't feel bad about it.—Stephen

An artist's sexual arousal ceases to be acceptable when it interferes with the legitimating process of art production. This breach may occur in two ways. First, an infringement may occur when the main goal or intention that brings the artist to the studio appears to be sexual arousal, when sexual excitement becomes an end rather than a means. To be acceptable, an artist must come to the studio with the intention of producing art. If arousal happens to occur, it must be unintentional and unanticipated, and it must occur during the production of art. Sexual arousal must not be enjoyed, but rather *used*.

If there's arousal, that's fine, because it's the by-product and it's not the goal.—James

A second breach in the legitimate use of sexual excitement may occur if an artist offers acknowledgement, verbal or nonverbal, of sexual arousal. Since acceptable arousal is unintentional, any conscious awareness of it is taken as a sign of an artist's ulterior motives and lasciviousness. Acknowledgment of arousal violates the unspoken agreement between artist and model regarding the legitimate uses of sexual arousal.

If somebody wants there to be a sexual element to this work there can be a sexual element. But it should not be brought across the lines. You know, I may be up there feeling sexual. I don't think anyone needs to know about that. I don't think I should have to tell them about that. If somebody out there in the audience feels sexual about me, I don't think they should tell me. If they came up to me and said, "You know, I think you're just so sexy," I would be offended. Because they can have their own private thoughts, they can think everything that they want. Great, go to it. Go to town. . . . Fool yourself, use my body to do your art. But don't let me in on it because that's your private world.—Tracey

STRIPPING AS SEX WORK

No matter how sensual or sexual their work may be, however, life models do not consider it "sex work" and are adamant that they are not sex workers. Strippers, they explain, *are* sex workers.

I'd had boyfriends who tried to get kinky on me about it and say, "Oh come on, I'm sure that you probably think about some of these guys, or they think about you, and they're probably lusting after you." And I just say, "Oh just shut up," you know? I don't care if they are or not. You know, the issue is: this is art. You don't understand, I am not a stripper!—Rachel

Both strippers and life models take off their clothes for money. Both acknowledge that their nakedness can inspire sexual arousal in their onlookers. Both refer to their work as an active performance, and both deny that their work involves intimate contact or sexual intercourse with members of their audiences. Both resent the social assumption that nudity necessarily correlates with promiscuity.[10] Yet life models adamantly insist that their work is not comparable to stripping.

I had a man say to me once, "Why don't you become an erotic dancer instead, and instead of making thirty bucks, you will make two hundred bucks in one night." And the thing is, the only thing they have in common is the fact they involve nudity. People watching nudity. That's the only thing that they have in common.—Tracey

While an outsider might find the difference between modeling and stripping trifling, the distinction is important to models. The distinction they make is similar to that made by Hollywood actresses who agree to do nude scenes in their movies but at the same time refuse to pose nude for *Playboy* magazine, despite the fact that their nudity may get greater exposure in a movie than in a magazine.[11] Life modeling is elevated by the pursuit of art; stripping is not.

It's a lot more satisfying. I work a lot more hours to make the same amount of money, but I don't dread it before I go, and I don't come home smelling like smoke. My feet don't hurt afterwards. Everything else usually hurts. Honest work. It just feels better. It feels more honest to model, more elevated.—Denise

Well, stripping is just a lot more playing up. The whole focus is sex, and the sex is sort of ugly, not beautiful. And with art modeling, even if it's clothed, I think that there is a sexual, or I guess you could say sensual, aspect with it. But there's more of the whole person, and it's much more of an artistic approach.—Natalie

The primary distinction models make between the practice of life modeling and that of stripping is intent. The intent of the stripper is to arouse the viewer. The intent of the life model is to inspire art, a process that may or may not be accompanied by sexual arousal.

The point is, above everything else, [stripping] is for sexual stimulation. With art, it's for anything you want it to be. That's the difference. If you

look at an artist's model, and you're turned on, that's great. And if you look at an artist's model, and you're not turned on sexually, that's great too. You see what I mean?—Tracey

You have a life drawing model doing very sensual, graceful, beautiful things, and you have a stripper that is doing that as well. The main difference is that the stripper or exotic dancer's main intent is to titillate, to arouse. Life drawing is not that at all. Life drawing is not to arouse or evoke or to titillate that kind of reaction. It's to evoke a sense of poetry in an artist so that they can convey that inspiration to that paper or to that canvas or to that clay. And if that involves them being aroused in the process, that's fine.—Irene

When pressed, life models find the distinction between arousal and inspiration difficult to locate.

It is essential that I know who I am and that I know what I am doing. I don't think strippers really know what they are doing. If they do know what they are doing, on the other hand, then I think there is a comparison. I think there is an overlapping.—Joan

There is a gigantic difference actually. What an exotic or topless dancer does has nothing to do with art. . . . But there is no doubt in my mind that what I am doing is part of art. And to me that's the biggest difference. But there are hundreds of differences between erotic dancers and models, most of which are escaping me right now, but I just feel the two are just entirely different, and really there should never be any comparison.—Robert

Certainly the impulse to distinguish between degrees of sexuality is not limited to the art world. For example, Americans tend to make a distinction between a woman labeled a "whore," and a woman labeled a "prostitute." Being called a whore is worse than being called a prostitute. Researchers explain this distinction by suggesting that a prostitute is seen as exchanging money for sex, while a whore gives sex away.[12] The prostitute is more respected because she works, earns money, and generally functions within the boundaries of the capitalist work ethic. Americans value work and the pursuit of work over leisure and the pursuit of pleasure. The whore is just out for a good time, and thus violates both the work ethic and the dominant sexual code of conduct. Prostitutes deny being whores. Strippers stress that they do not stoop to prostitution,[13] and life models insist they are not stripers.

Strippers and other sex workers typically see their employment as temporary or as a means to another, and more legitimate end.[14] Life models emphasize that the financial rewards of life modeling are too limited to allow life modeling to act as an efficient means to any other monetary end. Many Portland models could earn more money elsewhere—some had careers with

substantial salaries. They value life modeling for reasons that are intrinsic to the process of modeling itself. They usually plan to continue modeling as long as they are physically able to do so and as long as they are desirable to studios and artists as subjects.

ESTABLISHING THAT SERIOUS WORK IS HAPPENING

Although clear lines between sex work and sexual work may be difficult to establish with any certainty, the professional respectability of life models depends upon these very lines. How do they promote a "bright line" between what they do and what sex workers do? In nudist camps, residents are faced with a similar dilemma. The dilemma is usually solved by a set of written camp rules that include prohibitions on staring, sex talk, and dirty jokes. Body contact is also usually forbidden, and photography is controlled by the camp management.[15] These rules help to routinize nakedness and diminish its attention-provoking quality.[16] Similarly, spas often have rules governing the interactions between masseur and client, forbidding sexually explicit talk and prescribing that portions of the body be draped throughout the massage. No such formal codes exist in the artist's studio. What's more, formal enforcement of protocol among models and artists is extremely difficult given the relative isolation in which many artists and models work; there is no agency overseeing the individual transactions of artists and models. Because it is never explicitly laid out, the boundary between sexual work and sex work must be maintained interactionally. The life model does a great deal of conscious and semiconscious work in constantly reasserting the line between the acceptably sensual and unacceptably sexual. This boundary work comprises a set of techniques that the model employs to maintain a sense of privacy while publicly nude. And while it may seem odd that a person who is paid to stand naked in front of strangers would have many, if any, privacy needs, life models actually have very clear ideas about acceptable and unacceptable behaviors in the studio. Unacceptable behavior violates their privacy.

Upon arriving at the studio, the first thing a model must establish is that the studio is a place of work, not a place of pleasure. This is a two-step process. First, the model must establish that nothing extraordinary and certainly nothing salacious is happening. He or she must adopt what researcher Joan Emerson has labeled the "nothing-unusual-is-happening stance." Social interactions are routinely biased toward the "nothing-unusual" stance, and in most settings novices will "quietly cooperate with seasoned participants in sustaining a 'nothing unusual' stance."[17] A classic example of this behavior pattern is offered in Hans Christian Andersen's story *The Emperor's New Clothes*, in which only a child is willing to acknowledge the something-unusual circumstances of the Emperor's nakedness. Everyone else in the community pretends that the Emperor is dressed. As adults, most of us behave this

way. If a heterosexual man unknowingly wanders into a gay bar, for instance, he will probably avoid drawing attention to himself and will try to disguise his mistake, perhaps having a quick drink before quietly leaving, or looking at his watch as if it were the time, not the surroundings, that compels him to leave. Similarly, when a life model enters a studio, he or she will not acknowledge any unusual circumstances but instead try to make being naked in a room full of people as routine as possible. Any participant who calls attention to the unusual circumstances, rupturing this implicitly agreed upon veneer of normalcy, risks being labeled by other artists as an outsider, troublemaker, or even pervert.[18]

In addition to establishing that nothing unusual is happening, the life model must also establish that what *is* happening is *work*. If the art studio and the model's activities are seen as work, it is less likely that the model's actions will be interpreted as oriented toward pleasure or sexuality. Again, if an artist does experience pleasure while working in the studio, that is fine, but it must be a by-product of the artistic endeavor and not the goal. This "work" definition is particularly important in legitimating life drawing classes on school campuses, where the exposure of young students to anything remotely sexual is suspect. Indeed, according to the researchers Jesser and Donovan, schools stress that life drawing courses involve serious work for credits, toward a degree, or for self-enrichment, all of which are acceptable activities with long-range goals, and add that anyone with prurient interests would be denied admission.[19]

Because models, like other Americans, wish to disassociate work and pleasure or work and sex, they believe that they themselves should not have sexual thoughts or intentions while working.

> I had no idea whether or not there were going to be, you know, these sexual issues. . . . Soon as I took my clothes off and started working, I realized that wasn't an issue because I was concentrating so hard on where light was coming from, what sort of geometry that was creating on my body, staying still, and in some cases, even physical pain.—Russell

Artists, too, should be similarly engaged in the work of artistic production so that there is no opportunity for sexual thoughts or intentions to develop. Models describe their sense of what the artists should be experiencing in the following terms:

> You have to get your energy very, very focused on what you're doing in order to do a good job of it. You don't have a lot of energy to be thinking about sexual things with a model, even though I'm sure it slips into their minds.—Rachel

> [They] get so absorbed into all the details trying to get this to look like that. There's really no room for any kind of sexual element at all.—Patrick

While studios, art classes, or workshops can be social places, and models and artists can enjoy their time in the studio, this is not the main purpose of their studio time. For them, the assumption of a pose acts as a "keying device," marking the shift from sociability to work.[20]

> When I get down to it, right down to the business part of it, it is focused. It's clearly a change of energy. . . . Everyone is just like, "Okay, this is just a working person."—Susan

When members of the studio fail to adopt the work-is-happening definition of the situation, the legitimacy of the model's endeavors is threatened, and she or he must act to repair the breach. Such boundary violations are surprisingly rare. When a breach does occur, models tend to describe it as a vague sense that "something isn't quite right." Models usually attribute this sense to the "energy" that an artist "gives off."

> But then there are these people . . . they don't necessarily penetrate my space, it's just their orientation, their positioning. And their intent. I mean, I am a pretty perceptive person, I can just tell when somebody has got an agenda—Susan

An unacceptable sexual agenda represents a challenge to the serious work definition that the artist and model are expected to adopt. Sometimes an unacceptable agenda becomes apparent in an artist's work.

> Once, I was posing individually with a male, who I found out later was gay. The way he drew my body sometimes—like accentuating the penis— I felt a bit uncomfortable with it. Okay, fine, that is what he wanted to draw, but I started thinking what his real intentions were behind doing this.—Jonathan

These sorts of indiscretions are usually handled indirectly or are self-correcting. To resolve a situation indirectly the model might redirect poses so as to discourage the artist from exhibiting the inappropriate agenda or energy. Also the model might be more careful to avoid all visual and verbal interaction with the errant artist. Of course, all of us use these same techniques when we are slightly annoyed or bothered by a stranger's behavior. When approached by a panhandler on a city sidewalk, for example, we may look away and refuse to engage.

Other studio situations are self-correcting. As one model explained to me, "anybody who thinks the artists in a life studio are having fun hasn't ever tried it." The artists in the studio are typically very absorbed in their work, and the atmosphere is so work oriented that any artist attending a life session for prurient interests is likely to become bored after a few silent hours. There are many simpler, less constrained forums for viewing nudity: beaches, magazines, movies, strip clubs, pornography, television, and so on. Moreover, to attend a

figure session, an artist must not only pay but also obtain the necessary props, such as an easel, paper, brushes, and paint.

The importance of a serious work environment is one factor in a life model's preference for working with individual artists or small groups of mature artists over larger classes of students at high schools, colleges, or universities. Classroom settings typically involve younger artists in greater numbers. A class of twenty eighteen year olds may know each other outside of class and may be taking the class only to fulfill a university requirement, rather than out of any real interest in art.[21]

Younger students, you know, beginners—maybe it's more titillating to have a naked person in there, and it's, you know, just dealing with different energy, more scattered energy.—Susan

Lots of times they get together for social reasons, so they are talking all the time. You never know if they want the model or if they appreciate it. You know, I am there to work, so I don't want to be just hanging around, even if I am getting paid for it.—Joan

Still, most models say that they will accept work in schools and that in most cases even young students quickly learn that the studio is a work place.

Students seem to get over it fairly quickly. You know this is a class, and this is on the up and up. There is that initial sort of shock treatment so to speak, but most people deal with it real well.—Robert

The nothing-unusual definition of the studio setting is not dependent on cooperative interaction alone. Jesser and Donovan explain that the physical character of the art studio is also arranged to facilitate the serious work definition.[22] In the impersonal classrooms of university settings, little effort is made to enhance the appearance of the studio. It is a place to work.[23] Typically, classroom studios are designed in semicircles with a raised "stand" or platform in the center, where the life model assumes his or her poses. Artists arrange their easels or benches in front of, and to the sides of, the modeling stand. The number of artists that a studio can accommodate is, of course, determined by the size of the studio. In inferior, crowded situations, there may be two rows of artists. In most every case, however, a space of five to ten feet is maintained between the artists and model. This allows an instructor to stand in front of the class and move from artist to artist, and gives artists a clear, distanced view of the model so that the artist can see the proportions, shapes, and lines of the entire figure. This space also ensures that the artists cannot and do not touch the model. It allows the model to control, to a certain degree, what the artists are able to see. Shifting a pose, or leaning one way or another, can hide certain body parts from view. Although artists may walk through this space when entering or exiting the studio, or while visiting

with other artists on breaks, they do not enter this space when the model is on the stand. To do so would interrupt the work of the other artists by obstructing their view and would violate the model's cushion of personal space. Likewise, models do not leave the stand while posing or while naked.

Very small studios or individual artists' spaces are more flexible in physical design. Here more attention may be given to the overall aesthetic of the room. It may be cleaner, more organized, and even painted or decorated. In some cases, artists' living rooms double as their studios, and in such a situation, amenities such as music and beverages might be provided for the life model. The distance between the model and artist in these private settings may also be shortened. Yet, even in this intimate setting, a certain "privacy cushion" will be maintained, both for the model's comfort and for the artist's sense of perspective. In private settings, arranged by mature professionals, models assume that artists understand the nature of life modeling and respect it as professional work. Thus, they are somewhat less vigilant about boundary maintenance. Models like the idea that they may be working with the next "great master" and therefore playing a key role in art history.

FIVE

Maintaining the Line

Coping with Challenges to the "Serious Work" Definition

CHALLENGES TO THE SERIOUS WORK DEFINITION

IN ORDER TO CONSTRUCT the scene of serious work convincingly, life models must constantly monitor their own behavior and that of others in the studio. Often this work of "scene production" is contained in subtle maneuvers and details that appear inconsequential to outside observers.[1] Most prominent among the challenges to the models' scene production are the necessities of undressing and dressing publicly, managing verbal and visual contact and genital exposure, and dealing with erections and menstrual periods.

DRESSING AND UNDRESSING

Dressing and undressing present particular challenges to the life model's non-sexual definition of the art studio. Many models describe a brief but important "moment" that marks the transition from clothed to unclothed.

> *There is always that moment of going "Whoa." I mean, I still get that the first time my shirt comes off, or whatever.—Susan*

> *It's interesting because there's a moment, there's a moment no matter how long I've been doing it that I just sort of have to take a deep breath and go, "Okay, this is it," and you dive in. And you just go. It's almost like going to a party, and you know that your exboyfriend is there on the other side of the room with his new girlfriend, and you just decide you're going to*

49

have a good time anyway. "I'm not seeing this." That's really what it's like. You just dive in and do it. Take off your clothes, fold 'em up, put them on the modeling stand, and keep them close by.—Tracey

It's like going off the high dive. You just go up there and jump off. If you sit around and think about it, you won't dive.—Rachel

Putting on and taking off clothes are intimate, personal acts. And while dressing and undressing oneself may be considered mundane in our culture, watching another person undress—or being watched while undressing—is almost always defined as sexual. Thus, models experience dressing and undressing in the studio as sexual, while being naked is not experienced as sexual.

It's like you can be okay naked, but taking off your clothes in front of somebody is a private matter. It seems really ironic, I know. I used to change in a closet, put a robe on and then come out and take the robe off. So being naked in front of somebody is not quite as personal as taking off your clothes. 'Cause when you're taking off your clothes, you're actually a person. But when you're up there, if you're already naked, I mean it's a performance, you're already in a performance spirit. But taking off your clothes is not performance. That's practical, and that's personal, and not a lot of art models like for other people to see them undressing.—Karen

Yeah, taking your clothes off, that moment, the undressing, I think is the weird part, or the part where you feel the most vulnerable. Once your clothes are off, it's like okay, start it. Things are easier.—Natalie

When the model is undressing, she is not posing, and artists are not creating. Thus, her seminakedness is not being used in support of art. Watching the model undress is not a part of work, but perhaps pleasurable and thus calls into question the nonsexual boundary that is supposed to be in place. For this reason many models, females in particular, prefer to avoid undressing in front of artists whenever possible. This particular form of modesty is neither unusual nor limited to the artist's studio. In the United States, doctors routinely leave patients alone in examination rooms to undress, despite the fact that they will soon see and even touch their patients' naked bodies. This, according to James Henslin and Mae Biggs, is not accidental. By removing himself from the examination room, a doctor removes any suggestion that a striptease is being performed or that the nakedness of the patient provides any pleasure for the doctor.[2] Since work is not happening during the few moments it takes to undress, that nakedness is not legitimated.

Typically, models will use a nearby bathroom or closet to remove their street clothes and put on a robe, sweat pants, or oversized t-shirt. This tran-

sitional attire is what the model will wear into the studio and remove in order to take a pose. The goal is to make the transition from clothed to unclothed as brief as possible, thereby minimizing its possible construal as an erotic act.

> *Personally, I just go, and I kind of get ready in the bathroom, where I take off my underwear and my bra and stuff like that. I usually have a little shift or sweats and a t-shirt on, and I will take that off in there, on the stage—on the stand—just before I am ready. I mean getting ready in the bathroom and then coming out—that's all a function of not taking your clothes off in front of people. You want to be as naked as possible when you get there, so that it's not obvious that you are taking your clothes off.—Denise*

> *I usually find a bathroom, put on a robe. Whenever I don't, it does feel a little more sexual.—Emily*

Some models will choose whether to undress in a room separate from the studio or within the studio depending upon the "feel" of the group or the age of the artists.

> *I undress on the platform. Occasionally I'll do the robe thing, but it depends. I modeled for a high school, and there I had a robe. I just didn't know what to expect with these really young kids.—Natalie*

> *It depends . . . I always bring a robe. You go somewhere where you can change, and then you go in there. In a school, you would want to do it that way. I would probably find a bathroom and change there.—Patrick*

A number of other models, including a majority of male models, do routinely undress on the platform. These models are not trying to undermine the work definition of the studio. On the contrary, they claim that they undress openly for the express purpose of downplaying or routinizing the significance of taking off their clothes.

> *I do it fast, and I turn around to do it. I don't look at somebody and take off my clothes, because that's suggestive. So I turn around, and I try to make it a little private thing and make it quick.—Karen*

> *They will ask if I would like to go back behind this curtain or back to this room in this robe, and I always say, "No, this is fine right here." Because I like to be as casual about it as I possibly can. I feel that when you create a certain mysticism about the nudity it tends to make more of an ordeal out of it or more of a production out of it. . . . I simply go to the model's stand and then take my clothes off. I don't try to make a big production out of it.—Robert*

Both models who undress outside the studio and those who undress in the studio do so for the same purpose: to deemphasize what they are doing

and protect the work boundary. Many models who remove their clothes in the studio even object to calling the act "undressing," a word that has sexual connotations for them.

> I think you can shed your clothes . . . I don't undress . . . I just take my clothes off.—Emily

> I don't feel like I'm there undressing. I'm just throwing my clothes off fast, so I can stand up there and start work.—Leah

Wearing only a few items of loosely fitting clothing before disrobing has practical and professional advantages. Indentations on the body from waistbands, socks, and bras can be distracting to artists who are trying to focus on shape, line, and form. Wearing as few articles of clothing as possible to a session also minimizes the length of time required to remove the clothes, regardless of whether one "sheds clothes" or "undresses." The less time-consuming the act of undressing, models assume, the less noticeable it will be. In turn, the less obvious the act of undressing, the less likely the nonsexual definition of the situation will be breached.

> When I go to model, I usually try to wear some kind of loose-fitting clothes that can come off quickly so that the act of getting undressed is not a big ordeal. I usually do it right on the model stand, and it takes about a second, you know. The biggest thing is taking my shoes off. After that, everything goes. I just do it matter of factly, because it's not something that is part of the performance.—Victor

Underwear is a particularly problematic item of clothing. Underpants do not have the same meaning as other items of clothing such as sweaters, jackets, or shirts. Underpants, even more than other undergarments, are personal and intimate. We do not share them, and we only reveal them selectively. In fact, research has shown that women undressing for gynecologic exams express more concerns about doctors viewing their underwear than about the doctors viewing and touching their vaginas. "Most patients," according to Henslin and Biggs, "hide their panties in some way. The favorite hiding or covering seems to be in or under the purse. Other women put their panties in the pocket of their coat or in the folds of a coat or sweater, some cover them with a magazine, and some cover them with their own body on the examination table. It is rare that a woman leaves her panties exposed somewhere in the room."[3] Models, likewise, go to great lengths to avoid the possibility of others seeing their underwear. Some will use a changing room to remove their underwear before a session even if they plan to remove the rest of their clothes in the studio, on the stand.

> If I had them [underwear] on, I'll take them off. I mean I'll usually go to the bathroom and take them off before I start.—Natalie

Many models report that the best way to cope with the problem of underwear is simply not to wear any on the days that they work.

> I might not wear underwear or a bra that day so that I can just take off my shirt or my dress.—Karen

> I don't wear underwear usually, so I just get on the stage, then take my shirt off.—Stephen

Whether or not they undress inside the studio, most models believe that it is essential to dress, at least partially, during any breaks in the session. Dressing during breaks does not usually mean that the models put on street clothes. Instead, they will wear transitional clothing, such as a robe or sweat pants.

> Usually I like to make sure that I've got shoes that I can slip on and off easily—clogs or sandals, something like that. Usually I like to stick to wearing something to work that is going to be like a long shirt. . . . If I have a five minute break, I could just stick on my shoes and stick on my shirt and then I'm somewhat covered.—Tracey

Breaks range between five and fifteen minutes. During shorter breaks, models will often remain on the stand, rest or stretch. Holding a pose for an extended period can be very painful. Even short breaks provide relief and an opportunity to look around the studio, move stiff limbs, regain sensation in arms and legs that have fallen asleep during the pose, or use a bathroom. Since warmth is a constant problem for models—usually a studio warm enough for an immobile, naked model is too warm for the clothed artists—models often feel cold and will cover themselves even during the shortest breaks. They also want to maintain the understanding that their nudity is only for the purpose of artistic creation. Yet getting dressed for such brief hiatuses can be troublesome and potentially embarrassing to artists or models.

> Sometimes it's awkward getting dressed, because it takes longer getting dressed than it does undressed. And then you've got this rapport with people, and they want to talk to you while you are getting dressed about "Can you come pose for our group?" or "I really liked working with you today," or they might talk to you about something we talked about earlier, and they try to talk to you while you put your clothes on. . . . Sometimes I just, you know, roll up if they have a blanket there.—Karen

Leaving the stand during a break requires that the model actively maintain the nonsexual definition of the situation. The modeling stand, sometimes just a chair or box, serves as a physical reminder of the model's status as a worker.[4] While unclothed on the stand, the model is "nude." Off the stand, the model would be "naked." Therefore, if models leave the stand during a break, they will dress.

If it's really hot out, like ninety-five degrees or ninety-seven degrees, I might not really get dressed. But if I don't get dressed, I pretty much stay on the stage. I don't walk around among people.—Russell

Initially, I was surprised to learn that models who had been viewed unclothed for two or three hours at a time would suddenly feel a need to cover up in front of the very same audience for perhaps just five or ten minutes during a break. Yet the model's nakedness is only legitimized when it is present in the service of work, not sociability or rest. Models will only remain unclothed if they do not engage the artists in any social way. Similarly, if a model wants to talk with an artist, or if an artist wishes to speak with the model, the model will dress.

Before I talk to them, I put something on, even if it's just a pair of pants.—Charles

It's pretty formal. I mean, in general I'm pretty formal and I'll be dressed when I look at pictures and people talk.—Emily

LOOKING

Anyone who has ever been stared at or, conversely, been unable to make desired eye contact with another person, understands the importance of visual interaction. The eye has been described as having uniquely sociological functions, and the union and interaction of individuals based upon glances is "perhaps the most direct and purest reciprocity which exists anywhere."[5] Where eyes look, for how long, and what they encounter when they look are issues of some importance in the artist's studio.

In the United States we are socialized to perform "observer-evasion" when encountering nudity. Jesser and Donovan explain that when we unexpectedly encounter a person without clothing, we expect that the naked person will immediately try to minimize or hide his nudity from view and we, in turn, will immediately try to look away or evade undue observation. A person who fails to respond according to his role in this encounter risks being labeled either as a voyeur or as an exhibitionist.[6]

Yet the artist's studio turns these social norms upside-down. Models clearly cannot and do not seek to hide their nakedness. They are in the studio for the express purpose of exposing their bodies. Artists are there to look at their bodies. Unable, therefore, to rely upon socialized norms of "eye behavior," new rules must be established to govern the action of looking in the art studio.[7] What might be considered rude, or staring, or even confrontational on a city street might be normal eye behavior in a studio. Learning this behavior is a gradual process for artists. As they become more accustomed to the studio setting and to the presence of a life model, they gradually shift into this alternate, unique set of looking norms.

First, artists must look *enough*. Typically, they will move their eyes back and forth from the model to their work, resting their eyes on the model briefly before they return their eyes to their creation. Easels and benches are usually placed so that the artists only move their eyes, not the position of their heads or bodies, when shifting their view. It is essential that artists who work in realistic modes look carefully at the model; it is only by looking and studying that they can represent the nude figure. Novice figure artists must learn how to look at the figure; how to see lines, forms, shapes, and proportions, instead of just a naked body.[8] Many times I heard instructors admonish young artists: "Look at your model! You have to look at your model!"

Life models are bothered by artists who fail to look enough. The production of the finest art possible is the high calling to which both models and artists subscribe. By not looking enough, artists risk compromising the quality of their art, the noble construct that legitimates the entire interaction scene.

> [Sometimes] I look at people, and I'll know that they're not looking at me enough to make good drawings. I'll know the people who are looking a lot are going to have a way more realistic kind of well-proportioned drawing. But I never say anything to the students, 'cause I'm the model, not the teacher.—Leah

Models also interpret a failure to look enough as an indication that an artist may be uncomfortable with the model's nudity. Given that the life model has tried to establish a nothing-unusual definition of the situation, an embarrassed artist is upsetting. An embarrassed artist calls into question the sexuality boundary.

> Everybody was embarrassed, and so it made me embarrassed. . . . I felt that they were embarrassed or at least a little bit uncomfortable. Or it was a topic to be avoided.—Natalie

> I posed for high school students once, and I didn't enjoy that altogether that much. I don't know if it was immaturity or that they were uncomfortable with it and that's what made me uncomfortable with it. I could sense that they didn't know where to look. . . . Their eyes were shifting, and wherever I seemed to look, they seemed to look away.—Irene

If the artist is engaged in artistic work and is using the model properly, the model is not naked, but nude, and should be no cause for discomfort. If the artist is uncomfortable he or she may have a sexual agenda in addition to an artistic agenda, and that is unacceptable.

While it is essential that an artist look at the model enough, looking too much is also suspect. An artist who moves around the studio so as to get a particular view of the model is immediately suspicious. According to models, the artistic endeavor requires a nude model in a holistic sense, not the view of a

specific body part or aspect. Thus, trying to get a particular view suggests that the artist, again, is not cooperating in the definition of the situation as one devoted solely to the pursuit of artistic goals, but instead trying to satisfy some ulterior motive.

> One guy found every position that was my most exposed area and just stared at me. And I was like, "This person has got a thing going on. You're not here to pursue your art form, you have another agenda going on."—Susan

> His eyes almost gave it away. He was almost edgy while working. . . . [I]t's a disturbing situation. . . . His intention was just very different from what I thought it was going to be.—Jonathan

> Sometimes I'll do this bent-over pose, but my crotch is facing away, more or less away. Anyway, I found the instructor sort of moving over to get the view or something.—Natalie

Contrary to the popular stereotype of a passive model being physically put into place by an artist, in most studio sessions—either classroom or private—models have a great deal of responsibility for, and control over, the poses taken. Models are acutely aware of the view that they present to different parts of the room and thus, in some cases, to different artists. If an artist requires a view from a different angle, the model wants to be the one to move, not the artist.

Artists must also avoid staring. Staring occurs when artists fail to spend a sufficient proportion of their "looking time" with their eyes on their work.

> At the start of the class, she would bring her easel to within four feet of the stand. And even the professor was kind of laughing about it because she was just young, and she would stare at the model but not do a whole lot of drawing. There would be a stick figure basically.—James

In their effort to prevent too much looking, models avoid most eye contact with artists. Unless it is accidental and very brief, they explain, eye contact is unacceptable. It makes artists uncomfortable and might be interpreted as sexual, delegitimizing the goal of the session.

> It breaks their concentration, and that means in someway I am not doing my job. I mean, they need to be able to focus on me and to draw me. That's why they are there, and if it's me looking at them, it changes the dynamic completely.—Charles

> That could make them uncomfortable if you are looking at them. I will sometimes look at them just out of my peripheral vision, just because it is interesting to see. They are just so intense, you know. They are looking up, looking down, looking up, looking down, and drawing. It's kind of

interesting just to see. And sometimes, I will look around just to see, "Well, has anybody left yet?" But no, I don't look at the artists. It's okay to move your eyes, but it is good to look at a spot [a specific point on the far wall] for most of the time.—Patrick

If I look often or a lot at one person, or steadily, that's going to convey something to them.—Nancy

What I do not do is look at a female student in the class, any kind of concentrating on any female student. My eyes will never even land on them.—James

Of course, a model's genitals present a particular challenge to the problem of looking. A penis, the pubic area, and breasts are relatively small when compared to the overall size of the body, and also less familiar than body parts that are routinely exposed, so in order to portray them accurately, an artist has to look at them especially carefully. Such specific eye contact, however, is discouraged in our social norms: in the United States, we are taught from a very young age that we should make our eyes take in the whole person, not let them fix upon a single feature of a person. It is socially acceptable to fix upon another person's eyes, although fixing on the eyes can convey specific meanings of attraction, interest, or anger. It is not acceptable to fix upon any other bodily feature. To do so would be rude and make the other person uncomfortable, as anyone who has a blemish, a scar, or prominent birth mark will attest. Similarly, when encountering someone who is physically handicapped, "one is expected to remain oriented to the whole person and to avoid the expression of a precipitous or fixed concern with any single attribute."[9]

Clearly the principle of "diffuse attention" cannot suffice in an art studio. Close and particular attention is essential to the accurate portrayal of a model's body. And while close and particular attention to an ear, a nostril, or an ankle might be relatively straightforward, close attention to a penis, scrotum, labia, or breasts is much more difficult to negotiate. Still, life models expect artists to portray their genitals and to look at their genitals in order to do so. In fact, any failure to portray the model's genitals accurately is just as disturbing to models as excessive attention would be. They do not appreciate novice artists who often turn genitals into vague, blurry "areas."

If a woman is drawing my genital area, they should draw it. What are they gonna do? Leave it blank? That is ridiculous.—Liz

[He's] been looking at everything else really intently, so why not his penis, you know? But a lot of people idealize and draw in the penis and testicles and move on. And, actually, [it] ends up sticking out all the more because it is idealized. They haven't been following that line and looking closely.—Russell

*I see sometimes people might have a hard time drawing male genitals,
whether they're male or female. . . . They might either not draw genitals,
or they might draw huge genitals, but they have a hard time drawing what
they see in regard to that part of the anatomy.—Stephen*

If an artist cannot or does not look at the model's genitals, then the
artist's work will suffer. Since the production of art is the end that justifies
the entire studio encounter, anything that threatens the production of art
also, necessarily, threatens the legitimacy of the situation. So we have the
ironic situation where, rather than trying to restore a nothing-unusual def-
inition by averting the eyes from genital nakedness, the artists must main-
tain the definition of the situation by doing the opposite: paying particular
ocular attention to the genitals. An artist who cannot pay appropriate
attention to the model's genitals is indicating that she has some ulterior
sexual agenda.

At the same time, the band of acceptable genital attention is narrow. Just
as too little attention to the genitals indicates a breach of the nonsexual def-
inition of the situation, so does too much attention.

*I saw his painting, and he had painted in my genitals . . . in a way that
was untruthful to his view of my body. From his perspective, he could not
see my genitals in the way he had painted them. And I saw his painting
and became livid. . . . [The instructor] brought the man out and I looked
at him and I confronted him very directly. I said, "Look, in your painting
I see that you've painted my genitals in a way that I know is not truthful.
It wasn't in your painting before, and I know that I am not even lying in
a way that would expose that, and if it was okay with me that you paint
that part of my anatomy that way I would have taken a pose in which you
could paint it." I said, "You have to respect the pose I take." I am show-
ing what I am able to show, and if you paint something that I am not
showing you, I consider that a breach of my vulnerability, and I am very
offended.—Liz*

*Occasionally, I have taken into consideration, "Okay this is a forty-five-
minute pose, who is going to get to draw my dick for the forty-five min-
utes," you know? It's something to consider. Who is going to react well,
or perhaps who would I like to be drawing it for the next forty-five min-
utes? It's important.—Charles*

If, while they are modeling, models are portraying or emitting only human
sensuality, not individual sexuality, then perhaps it should not matter who
sees what part of their body. The artists should simply portray whatever they
see. Yet models sometimes believe that they must consciously design a par-
ticular view for a particular artist, especially when that view is of genitals.

Unacceptable Poses

Although life models argue that the human body in general is beautiful, natural, and good, they do not grant this approbation to every particular pose or position. In fact, models give considerable attention and thought to the positions they will and will not take during a session, whether in a private or group setting. They believe that certain poses are bad, evoking unacceptable sexuality. As in the distinction between work that is sexual and sex work, sexual poses are encouraged for their inspirational qualities, while sex poses are discouraged as overtly eliciting sexual arousal. "*Playboy* poses" is the label that models give to sex poses, and both male and female models say that they avoid such poses.

> I've had people tell me that they've had models that would come in and strike Playboy-like poses. I have some friends that are art teachers, and he [an art teacher] was telling me, "Oh yeah, I had this one woman come in. She had a beautiful body, and she kept striking these provocative poses, like they would in Playboy, and I just never asked her back." She probably just didn't know any better. She probably just thought it was what she was supposed to do.—Rachel

Every model knows what a *Playboy* pose is, yet they find it difficult to explain to an outsider.

> Oh, um, that's a little cheesy, or you know gutterside . . . possibly the look on your face, possibly the position of your mouth. I think it would be the attitude, you know, cheap girl.—Emily

I came to understand that, typically, a *Playboy* pose is a more languid pose, in which genitals are prominently displayed. Such poses often include the model touching his or her own genitals. In general, both male and female models try to avoid *Playboy* poses or poses that they find overtly sexually arousing.

> I don't lay like that, legs apart. . . . What are they actually seeing? That's a really big question. What are they actually seeing? Not with their eyes, but with their heads.—James

Female models are more concerned about this issue than are males. The lessons of what has been called "limb discipline" are taught to American girls early and continually and include admonishments about keeping their legs together and their arms close to their bodies.[10] In parades, beauty queens wave with elbows low and close to their bodies, moving only their forearms, keeping their underarms from public view. And, by sitting with their ankles or legs crossed, ordinary girls and women keep their genitals from view. Since for a female model, unlike a male, genital exposure can be a conscious choice, such exposure becomes more problematic and

imbued with meaning.[11] A male's penis is external and will be visible on a male life model regardless of his desire to have it seen. Even in nudist camps, predicated upon the routinization of the naked body, "the female genitals because of their hidden character, never become a routinized part of camp nudity; thus their visible exposure does not lose an attention-provoking quality."[12] For the female life model, unacceptable poses involve touching genitals, and limb discipline amounts to avoiding poses with spread legs. Breasts, which like the penis, cannot be hidden, are not subject to similar control.

Models do sometimes take "sexy," as opposed to sex poses.

> I'm up there, and I really enjoy having people look at me, and I enjoy being in my body, and it makes me feel attractive, and I do sexy poses. I'm not talking about erotic poses. I mean I never spread my legs. In fact I've done it a couple times before on accident, where I'm sitting there in a pose going, "Oh holy shit!" You know? Like, "Oh my God, I can't believe what I just did!" But I can't move. I'm stuck there for five minutes. I never spread my legs. Never. That's not appropriate. And I never touch myself in an erotic way. Never do it. But if I want to flick my hips or toss my breasts out, or if I want to throw my head back or something like that, that's really good. I think it just helps people get inspired. It's just natural.—Tracey

Models' own explanations as to why they do not pose with spread legs typically refer back again to the intent of the pose.

> It's too much into looking like stripping or posing pornographically. Pornographically there is a very blatant attempt to illicit a sexual reaction, whereas artistically, a sexual reaction may be very much subjugated.—Natalie

Less frequently, female models offer as an added explanation the rationale that genital exposure simply is not necessary, given the wide variety of attractive and interesting poses which the model can assume without spreading her legs.

> I would not do a sitting or standing position with my legs spread way apart. Personally, that feels a little too exposed to me. That feels like I'm flaunting the boundaries a little too much. There are an infinite number of poses that are intriguing, beautiful, nice to draw from all angles without doing that.—Irene

THE PARTICULAR PROBLEMS OF ERECTIONS AND PERIODS

Making her labia accessible to the artists' gaze is a matter of choice for the female life model. Other physiological processes that also expose models in

potentially sexual ways are not under the models' conscious motor control. Most notable among these unconscious behaviors are penile erections, nipple erections, and menstrual bleeding.

Getting an erection while modeling is considered to be very unprofessional. Models have a difficult time explaining exactly why an erect penis is taboo, and usually resort to claims that erections would make an artist uncomfortable.

> For me it has a lot more to do with the comfort level of the other people. I guess in its own way, it's a sort of unspoken taboo. It does change the dynamic immensely. People have trouble concentrating when they see something like that. If they are ignoring it, they are conscious that they are ignoring it, and it pulls them away from the drawing. I think that at least in the United States, it's so unusual to be in a room with nude people, that to do anything to suddenly make it tangible in a sexual way is really disturbing for people. I'm sure for some people it is really very arousing. But that isn't what the job is about. The job is about something else.—Russell

> Because it's distracting to the students. They've got to be looking at this distraction instead of looking at the body. . . . Well, gosh, everybody has got to be sitting there staring at that erection, and they're not going to be focusing on the shoulders and the thigh and all this kind of stuff. And I imagine it's embarrassing for some of the students. It would be distracting. It's distracting enough for some of the newcomers to have a nude person in front of them, let alone having a hard-on.—Rachel

Presumably, a distracted, embarrassed, or uncomfortable artist would not be concentrating fully on the artistic endeavor, and therefore his or her product would suffer. Other male models explain that an erection would be personally embarrassing. While male models are not embarrassed by artists working from their flaccid penis, they would construe attention to an erect penis as a frightening invasion of privacy.

> Because you're not supposed to see it, basically. I mean, if you've seen that, there isn't anything you haven't seen. I mean, there isn't anything about my body that you don't know at that point. It's so hard to explain.—James

> I suppose it is showing your vulnerability or something like that—or that people might laugh, might get embarrassed. And then they would start laughing because of that.—Donald

There is a substantial body of folklore or mythology surrounding erections among life models. Virtually every model I spoke with had a "model-with-an-erection" story, but most said that they had no personal experience with this problem. Typical of the stories told over and over, in slightly differing versions, are the following scenarios:

A friend of mine was drawing somebody once, and she was in high school at the time, and she was drawing this guy. This was in Baltimore. I'm pretty sure the guy was a junkie. He was essentially off the street and getting some money modeling. And as he modeled, he kept getting an erection. It would go up, and he would smile and then it would slowly go down and he might frown a little bit. And it would go up and he would smile. And finally, the teacher called a break and said, "Can you do this?" You know, "Is everything alright?" And he said, "Yeah, I 'm fine," and she said, "Well you keep getting an erection," and he said, "Well, I'm more comfortable with it up," which I thought was really interesting. But I know that everyone in the class was really sort of freaked out by it.—Russell

Oh it was funny, I heard it happened once. This young boy came, and he kept going up and down, up and down, and finally the instructor just very politely says, "Okay, that's enough for today thank you." He just could- n't control himself. He was too young.—Rachel

There was this one guy at the Art Institute who is a huge, really big kind of tall guy, really kind of a giant, and he would always have an erection and then walk around and say, "Do you want me to put a rubber band on it?"—Leah

Most male models say they are, in fact, unable to get an erection while modeling, either because they would be too scared or because the physical exertion required to hold a pose demands too much attention and causes too much pain for them to experience anything else. Yet all have given consid- erable thought to the question of, What if? Most take preventive steps, which can be quite time and energy consuming.

When I'm modeling, I'm concentrating on one thing very much, and that's basically trying to remain calm [i.e., not erect]. So I don't have any lofty ideas about that. I simply am trying to remain calm in an acceptable way. And that's usually for three hours, three hours without giving in. I was told that that would pass, but it hasn't. On the whole, 10 percent of my energy is spent keeping my body up, the other 90 percent is resolving that one problem.—James

Various erection prevention techniques that models report include concen- trating on some other, mundane aspect of the studio or pose, inflicting some sort of distracting, physical pain on themselves, or thinking about upsetting and decidedly unarousing things such as a recent fight with a partner.

I'll look at peoples' feet. If it's a long pose, and I am already hurting, I will concentrate on that.—Donald

Generally I inflict some kind of pain. For instance taking my pinky of my right hand and digging it into my thumb. You can see the nail right here. That inflicts pain which takes my mind away. Thinking of relationships that went badly in the past, they do it real well. Also tensing all muscles up, just tensing them all up so that everything is . . . making the blood supply go everywhere. And if all else fails, I'll shut down breathing, and I get hazy, and the body starts worrying about other things.—James

It has never happened. If it ever starts to, I just divert my thoughts to baseball.—Timothy

If a model does get an erection, he must make a decision either to try to ignore it and continue modeling or to break the pose and cover himself. Breaking a pose is considered highly unprofessional and, as such, is a danger to the model's pride and self-respect. For this reason, most men explain that if they ever did get an erection while modeling they would, under most circumstances, try to hold the pose despite causing themselves considerable embarrassment. If the erection began to compromise the quality of the model's pose, then he would break the pose, since a breach of professional conduct had already occurred.

I might consider going ahead and just holding the pose, because the pose is what is most important. And, it's usually a temporary thing, I mean it's gone in at most a half hour, fifteen minutes, I would say. But I have never, never, never allowed that to happen. . . . If everything fails, I'll break a pose. If it's a standing pose, I'll definitely break it and fake a foot cramp or something.—James

For women, the only visible physiological response comparable to an erection are erect nipples. A few female models do express concern about this. Because breasts are not subject to the same display rules as penises and labia, however, concern is not widespread. Moreover, erect nipples on a naked model can easily be passed off as an involuntary response to room temperature, while an erect penis cannot.

Perhaps more equivalent to the male model's pervasive concern with erections is the female model's concern over menstrual periods. Since a modeling session will usually last about three hours, some provision must be made regarding menstrual bleeding. Most female models report that if they have their periods when they have a modeling session, they will use a tampon and insert the string along with the tampon. Like an erect penis, a tampon string must not be shown in the studio.

Well, same thing stripers do . . . hide the strings, you know. And only twice have I had a bad experience. And they were both this year. I've been modeling for a long time, and I'd never had that problem because that

scares the hell out of me. If somebody would see that. The first time it hap-
pened it was for a high school class. I got it at school right when I got there,
and I was like, "Oh shit!" And high school students! And . . . the ones
[tampons] that you get in the machines aren't very good, so I had a
blowout, right? And I didn't want to embarrass the boys because high
school boys would just freak out with that kind of thing. So anyways, I am
sitting there. . . . I was sitting on my sweatshirt. . . . I was really, really
embarrassed.—Karen

Often models will take secondary precautions in case of a "blowout." Typi-
cally, they bring something dark to cover the stand so that any blood will be
less obvious when they change positions or take a break.

If I'm on my period then I make sure that I have a tampon. So I put in
the tampon, and I just tuck up the string. Then nobody knows. Although
that's always a little edgy. If I'm on my period, I try to bring a black shirt.
I'll put the black shirt down so that if I, by chance, have a little spot, then
it will be minimal. It will be discrete. 'Cause these are just things you have
to deal with.—Tracey

In almost every case where a female model reported an unexpected onset
of her period while posing, she claimed it was less shameful to continue pos-
ing despite visible blood than to break a pose.

The second time was last Thursday. It was for one of those one-on-one
deals, and it was a standing pose, and I was "swoosh" down my leg. . . .
I said, "You know, I know it, but just deal with it because the heater is
on, it's already drying, it's already dried to my thigh." I said, "Just deal
with it," like I didn't want to make an issue of it.—Karen

By holding their pose, despite an unexpected erection or menstrual
period, life models reassert that work is happening and try to reestablish the
nonsexual definition of their situation.

TALKING

Models believe that artists concentrating on the production of art and the
acquisition of artistic skills should be too focused on their work to engage in
idle conversation. During work, life studios tend to have an almost librarylike
quality to them. The artists do not talk to each other, and although the stu-
dio is not silent, the only sounds are the sounds of artists at work: hands and
charcoal moving across paper, brushes being rinsed, pages being turned.[13] But
before class, after class, and on breaks, there will likely be sociable chatter
among the artists, and it is the life model's undressing or dressing that acts as
the keying device for this transformation. Silence accompanies work and the
model's nude figure; talk accompanies social time and the model's clothed fig-

ure. If talking does occur during the work portion of the session, it is usually only the instructor acting as an interpreter or chaperon, much like a female nurse present at a gynecological exam.[14]

Although rules governing artists' conversations amongst themselves are fairly clear, whether or not the model will engage in conversation with the other members of the studio seems to depend upon a number of factors, perhaps most prominent of which is the size of the studio. Models posing privately for single artists and over an extended period of time are more likely to talk with that artist while in a pose. Alternately, posing for art classes or younger artists usually calls for stricter boundary vigilance and means that models usually will not talk with the artists while they are posing.

> When I'm working for artists privately, a lot of times there will be more dialog that goes on. While I'm in a pose, and they're painting or sculpting, we may have a conversation. But in a classroom setting it tends to be different. There tends to be not much dialog. There are typically more people that are working, and I make an effort to be present in a more anonymous way. I am not taking time to try to get to know people other than to make brief eye contact with them.—Stephen

> When I model in large groups, I never talk to the people I model for. . . . And I don't sit around and chit chat with the students. But when I model for one person, when I take a break we'll talk.—Leah

In classroom settings, models often limit their verbal interaction with students during break time as well as work time.

> I go off and I am by myself. [I'm] not very friendly to the students, so I don't really give people the opportunity to come up and talk to me.—Leah

Generally, models object to being spoken to by clothed artists while they, themselves, are unclothed.

> Usually I don't talk to people while I don't have any clothes on and they do. When the session is over or someone wants to actually approach me and talk to me, then I usually put my pants and my shirt on and then have a conversation. . . . I need all the people in the room to know that I'm working as an art model and posing without clothes. . . . I don't just live my life that way.—Stephen

Artists, too, understand that clothed persons and unclothed persons do not interact verbally. In my research, I was at first offended by the common habit among artists of discussing nearby models in the third person. Once, when I was talking with a male model during a five-minute break, I was surprised to have an artist approach the two of us and ask me, "How many different poses did he take in this last session?" Neither the model nor the artist seemed to

find this third-person address unusual.[15] And gradually, I came to see that this awkward speech pattern was part of maintaining the serious work, nonsexual definition of the situation.

Attempting to talk about money with a model who is unclothed is considered an especially egregious breach of professional conduct. Several models reported that they had quit working for particular artists because the artists had handed them their checks before they were fully clothed. Financial transactions while naked, of course, raise the specter of the sex worker, an image that life models are trying to avoid. Models want to be paid at the end of a session, when they are fully clothed and off the stand. Certain other types of talk are also particularly unacceptable. Artists must never talk about the specifics of a model's body, whether in a complimentary or derogatory way. Such talk would suggest an adherence to a physical aesthetic that is supposed to be irrelevant in the art studio, where all examples of the human form are equally beautiful.

> There have been a couple times I've modeled in the class where there had been someone in the class that I didn't feel comfortable with. They made sort of a comment. There was one gentleman once made the comment that I had a nice tush . . . and I just kind of went, "Oh God!" That was not okay, and that was uncomfortable. I just felt horrible.—Liz
>
> I had breast implants for a while, and I've since had them taken out. I got real sick from them. But it left scars, and I had struck a pose in one class where the scars were showing, and I heard one of the students talking about it. She was just really disgusted with the fact that I had implants or breast enlargements. I heard her discussing it with another student. That was another incidence of being shamed by a student, and that stuck with me for a long time.—Rachel

While a pose may be good or bad, beautiful or ugly, a body or body part cannot. Although artists' preferences in body types change over time, all bodies are equally worthy of the artistic study of line and form, and each body type presents a different technical challenge to an artist. Thus, when an artist comments judgmentally on a model's body part, the artist is using a nonartistic referent for his evaluation. In other words, he is making a social or sexual evaluation that breaches the agreed upon definition of the studio as a place of artistic work.

> I had one experience where it was at the community college, and it was a watercolor class, and I love the instructor. The woman is a real sweetheart, but she had this older woman in there, and I had struck a pose where my derriere was facing her and she literally said, "Get your butt out of my face." It just shamed the hell out of me. You know? I just kept the pose, but it was real hard for me for the rest of the session to not want to glare at this woman or say something derogatory to her because she had shamed me like that.—Rachel

When models pose nude, they are working. They are not "standing around naked." This means that an artist should not make reference to the model's body in a way that suggests that the model is not giving a special performance.

> I was modeling. My arm was up, my head was down, and I was frozen. . . . And somebody, it was a woman, came up behind me and whispered in my ear, "Tickle, tickle, tickle." But it was so off, and I think she was trying to be funny, or friendly, or familiar in some way, but it was not somebody that I knew or was friends with, and it just made me feel weird and mad. I knew she was not trying to do anything wrong, but she had.—Victor

Covering the body with clothes is not a necessary condition for a "pattern of modesty" to exist.[16] Patterns of modesty are quite common in nudist camps, where residents are without clothes most of the time. Likewise, strippers report circumstances under which they feel their privacy to have been violated and try to structure their work environment and activities in such a way as to protect their privacy. Even Mardi Gras parade strippers, despite exposing their breasts on public streets, claim to create a sense of privacy, which can be violated by uninvited voyeurs.[17] Life models, too, create privacy boundaries despite being publicly nude. These boundaries serve to protect the model's sense of professional legitimacy and as such are carefully maintained.

SIX

"Denise"

DENISE ARRIVED FOR our first interview dressed like any other Portland woman in her early twenties: jeans, a t-shirt, and a fleece jacket. With shoulder-length dark hair and no makeup, she still had the fresh-faced look of a young college student. She was thin and energetic. Her speech was peppered with "like," "cool," and "you know." She had been an easy interview to schedule. She was excited to be part of a study, and she was eager to please: she worried about giving the "right" answers or that her answers might "wreck" my research. She arrived exactly on time for our interview. Later, I would learn that promptness and reliability are virtues common to life models. Because their work is irregular, occurring at odd hours, on different days of the week, and in different locations around town, they grow accustomed to scheduling appointments over the phone and arriving on time for those appointments. In all of my months of interviews, I had only one person fail to show up for an interview and almost never had to reschedule meetings. In fact, I learned that if I wanted to arrive a few minutes early to collect my thoughts before we began, I would have to arrive very early indeed, since many models also arrived before our appointed time, with the same intention.

Many models first learn about life modeling while they are in college, taking art classes either as part of their major or to fulfill general course requirements. Denise, however, had been introduced to the work of art modeling earlier than most when she took a life class in high school. She liked the class and decided to pursue a bachelor of fine arts when she went to college. There, her interests quickly moved away from figure drawing, toward photography and illustration. She finally returned to the life studio only seven months before our interview and as a model rather than an artist.

She was reintroduced to life modeling by her boyfriend. She'd moved to Portland shortly after finishing school and needed money. Her boyfriend told her how models in Portland earned ten dollars an hour, well above minimum

wage or the entry-level pay at most local jobs. At first she thought of life modeling as "*a part-time-make-money-now kind of scheme*," but after a few months, she began to think she might stick with it for a while. She was building her reputation and getting more work.

> For the first couple of months, I only got three gigs a month. For the third month, I got four. And for the fifth month I got eight. In the sixth month I got twenty, and this month I have had quiet a few, and I am getting more all the time.

Much of Denise's work came at "short notice." Like other models, she added her name to call lists and also became known by word of mouth. A day or two in advance of a session, typically, schools or artists start working their way down their lists. Denise liked the variable, almost haphazard nature of life modeling.

> I don't really want a traditional job. I am one of those people who is, like, afraid of rush hour traffic everyday. I couldn't do that. I couldn't go to the same place every day. And this is great for that. You get a variety of places that you go. You are your own boss, and you are fending for yourself. And you train yourself. . . . That is satisfying because nobody else can really take credit for it.

What's more, Denise said, she was honored to be part of the creative process. She was impressed that artists worked so hard to improve their technique, often with little tangible outcome.

> So many people put so much work into it, just into improving themselves. And they throw it [their artwork] away afterwards . . . hours and hours, and they throw it away. It's just the process. That's really cool.

As a novice, Denise was still learning how to be a good model. She tried to prepare for modeling sessions by reviewing the paintings of great masters. In particular, she was drawn to Degas's paintings of ballerinas. When taking poses, she recalled her life drawing classes at school and thought about what she found most appealing as an artist. She had learned that some poses are better than others.

> I like to do gestures by letting part of myself fall, you know, like making a motion and then arresting it? And I have noticed that opposing things, like taking the big masses of the body, like the top half or the bottom half, or the rib cage and the pelvis, and opposing them in some way make it very interesting. Instead of having everything aligned.

By far the most difficult aspect of Denise's work, she said, was holding still once she had assumed a pose. Denise told me that she thought she was improving but that she still needed to develop her skills. In particular, she was

trying to figure out how to "zone out," "meditate," "float away," or "go away," as so many models describe the altered mental state that allows them to handle the pain of a long pose, without moving.

> *Holding still. That's the only hard part, really. And in a way, that has been the really educational part of it. I have learned to kind of enter this meditative state. On these kind of long poses, like forty-five minutes, where I would pick something stupid, and I have fifteen minutes left, and I am dying, and I am not going to make it, and then I get suddenly switched off. . . . So I am learning. I think I just did it a month ago for the first time.*

Denise admitted that she still made mistakes, either by entering poses in a thoughtless, mechanical way, or by assuming poses she couldn't maintain. She seemed genuinely embarrassed, or even ashamed of her mistakes. She remembered every detail, even if her only error had been to end a pose five minutes early.

> *I had my arm up high and resting on my boyfriend's shoulder, because we were modeling together. I couldn't rest it there the whole time because it was too heavy for him to hold up and keep standing for forty-five minutes. So I was having to hold my arm up for forty-five minutes, and it totally fell asleep. I broke the pose five minutes early.*

Still, most of her modeling experiences had been positive. One session in particular, in a wealthy suburb of Portland, had been her best appointment to date.

> *She was having her mother in to teach a class for herself and a few other ladies from Lake Oswego. So it was in this real posh living room, you know, on a nice stand where they used to have a wood stove, and now they have a nice plush carpet and pillows, cushy pillows. They have a very nice state-of-the-art ceramic heater and studio lights and everything set up, and everyone had their nice little wooden easels and their perfect boxes of paints. It was like, God, how do these ladies afford all that stuff? They all talked about how their husbands are remodeling their houses. God. Anyway. That was like a peak experience, definitely, like the best you can hope for—a bunch of old ladies.*

Having begun to model as a young woman, Denise felt that her work was helping her to become a more mature, self-confident adult. Like most models I met, she told her family about her modeling work. Her father's response had startled her, but in confronting him, she had taken a step toward independence.

> *I told my father over the phone, and I never imagined that he would have any reaction to it. And he didn't. Then a couple weeks later, I was talking*

to my sister, and she said, "Dad just went into a decline about what you said." And I said, "What?" And she said, "You are modeling! He can't believe that you are accepting money from artists for your living." Like I was a concubine or something! Of course, he has read the biography of Picasso and people like that, so I guess that's what he had in mind. I was offended that he was shocked about it. I was really offended, and I let him know about it in no uncertain terms.

Outside of her family, Denise enjoyed playing with the reactions she got from people when she told them about her work. By posing nude for a living, she gained an aura of intrigue, a certain power over strangers and new acquaintances.

Because Denise's boyfriend also worked as a model, and since he had even introduced her to the job, he understood and respected what she was doing. When jealousy issues arose, as they sometimes did, the two of them were learning to be patient with each other.

I know exactly what he feels like if he is questioning me about who I am modeling for, because I question him exactly the same. He was doing a portrait sculpture for six weeks, and one of the students hadn't finished, and she was the one who was, you know, kind of good looking and had a really obvious crush. She asked him to come over to her studio afterwards for a final session. He was teasing me about it because he knew I was aware of what she was up to, but anyway, it came out okay. He is the same, [he] gets a little snappish around it. But we both understand.

When I began my research, I imagined that most men and women who worked as life models must possess extraordinary self-confidence about their bodies. And many whom I met did. At the same time, however, many told me that they had begun their modeling careers with great insecurities about their bodies, and that they had found in their work a means of achieving a more positive body image. Denise was such a case. She said she had suffered from bulimia during college and that she had gone into therapy for her negative view of her body. Life modeling was helping her to improve her self-image in several ways. For one thing, like many models I spoke with, her work encouraged her to maintain good eating and exercise habits.

I really think it has helped. Just as a motivator. On the very lowest level, you know. When you think about eating a cookie you think about your six o'clock appointment, you know, and how the light is going to be falling on the back of your thighs.

Through posing nude, Denise was also forced to come to terms with the exact proportions of her own body.

I was really confronted with exactly, you know, with what the outer dimensions of my body are . . . no more and no less. No minimizing and

no maximizing. Otherwise, as a kind . . . a neurotic woman, I tend to look at myself, and either I look skinny, or I look really, really fat. But I am neither. I am not skinny, and I am not fat. And it was confronting to have to deal with exactly what it is, but in the same way it kind of took pressure off. Like that's exactly what it is, there is no way around it, so you can just accept it.

Modeling had taught Denise to be more appreciative of the body's beauty in its myriad forms.

I think it affected the way I think about the human body in general, and my body personally, because even fat ladies and old saggy men, or really skinny people, or you know whatever, people different from yourself, they got naked and they sat still. And you could look at it and find some part of it with real harmony and beauty to it.

Denise was not at all concerned that by posing nude, she might be allow-ing herself to be objectified. In this respect, she was typical of young models: she accepted objectification as a fact of life and reinterpreted it as a source of power and pride. She did not care if an artist might become sexually aroused by looking at her; she believed that a lot of art is sexually inspired. She rel-ished being a shape or object capable of inspiring.

You are objectifying it [the body]. There is no way it can't be objec-tive. . . . Because that's what it's all about, subjecting it [the body] to interpretation. You sell your body as a shape, a bunch of textures, the way the light falls on it.

Denise had her own way of looking at things—a confident individualism she had gained in large part through modeling. She was untroubled by potential feminist critiques of her work, and she was not political in any organized way. When we met, many models in Portland were working to organize a guild, which she had joined. But she used her membership only as a referral source for work and did not get involved in activist efforts to improve conditions at local schools, and so on. For her, things were going well enough.

Life modeling is not Denise's ultimate career goal. Like many people her age, she is unsure of what she wants to do as a long-term career but feels that there is plenty of time to figure it out. In the meantime, life modeling pro-vides her with some income and work that she enjoys. Like many life mod-els, she is excited by the possibility of one day seeing herself and her work in a museum or gallery.

Wow, that would be so cool. . . . I haven't been [had my portrait appear] in a real prestige place. That is like the ultimate gratification, when some-thing important happens and, you know, the model really is part of it.

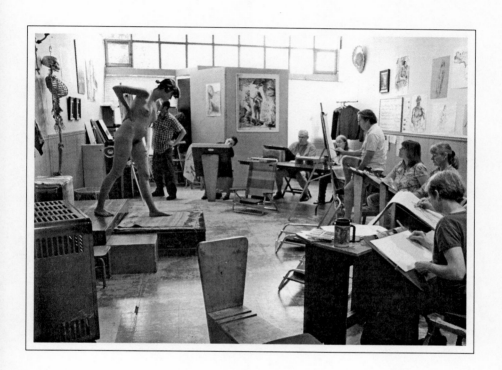

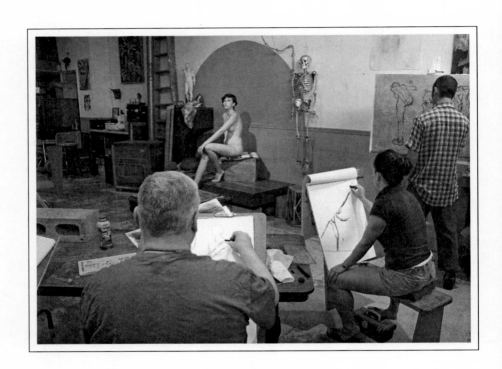

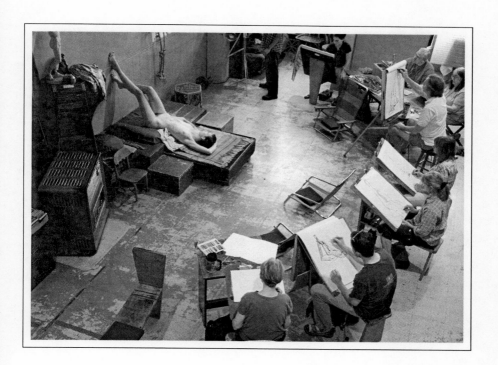

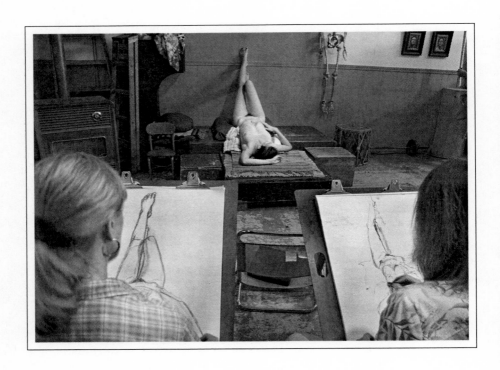

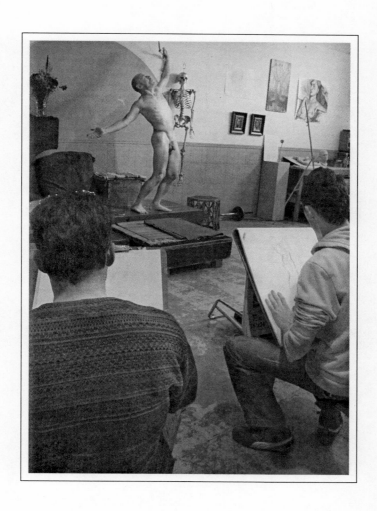

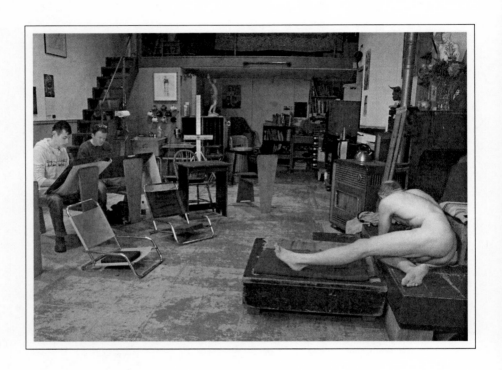

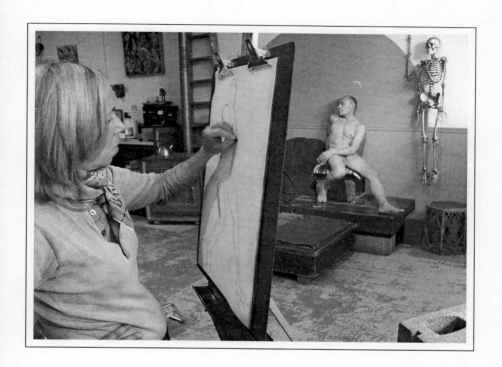

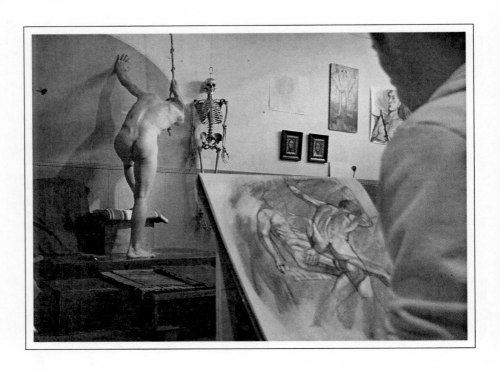

Modeling Gender

Social Stigma, Power, and the Penis

Depending on the social context, anatomical exposure may be conceptualized as artistic, erotic, healthful, or even cute, or it may also be defined and labeled as pathological, perverted, and/or criminal.

—Bryant, *Sexual Deviancy in Social Context*, 100

SOCIAL STIGMA

A SOCIAL STIGMA is an attribute that is discrediting to the holder. According to Erving Goffman, social stigma can take three different forms.[1] There are what Goffman has called "abominations of the body," which include physical handicaps or abnormalities. There are putative blemishes of individual character, such as addiction, mental disorder, and unemployment. And then there are those stigmas associated with group membership or lineage such as belonging to a stigmatized race or religion. To work as a life model is to court disgrace in the second respect. Yet the nature of social stigma is complex. For while few parents would include "life model" on a list of career aspirations for their child, by virtue of life modeling's association with art, it does have some cultural capital. Perhaps not a "respectable" job, it is nevertheless seen as bohemian and artistic.

Life models realize that their work is not socially acceptable in the way some other lines of work might be. For the most part, they attribute this negative perception to ignorance on the part of the general public and to an extreme discomfort with nudity in American culture.

> *I get the perception they just think we're a bunch of perverts out there rip-*
> *ping off our clothes. If it wasn't for us, we wouldn't have a lot of the great-*
> *est works of art. I mean, there's a purpose for us. Whether we're some-*
> *what perverted or not doesn't matter. We're certainly not hurting*
> *anybody. Whether you're a stripper or whether you're a nude model, any-*
> *body who has the inclination to take their clothes off and feel natural in*
> *front of somebody has got to be a little bit weird, as far as most people are*
> *concerned.—Michael*

As with any stigmatized profession, it is difficult for outsiders to understand that a person might deliberately choose to become something that the general public holds in disdain. For example, most people assume that a person, usu-ally a woman, will only become a stripper as a last resort, when all other efforts to find employment have failed. The fact that this is not what most women who strip report—they choose their work because of the high pay and flexible schedule—is too disconcerting for many outsiders to accept.[2] This difficulty in accepting the realities of a stigmatized profession is clearly illustrated in acad-emic debates over whether or not a woman can "choose" to become a prosti-tute. Even when women say that they have chosen prostitution as a profession, and list rational criteria for their decisions, many scholars still argue that they have made their choices under duress or that they falsely believe they have made a choice, when in fact prostitution was forced upon them by social cir-cumstances. Every model I spoke with told me that she or he had chosen to be a life model and wanted to be one and that the benefits of the job far out-weighed any associated problems. One of those problems, however, was a feel-ing of constantly having to justify their career choice to a public that, while appreciative of art, is disdainful of the models who pose for that art.

> *I get the sense from them of, "This is all you can do?" You are doing this*
> *because you can't do anything else, and you just sit there. It's this big thing*
> *that society has, this naked thing. Naked and lazy are not very appreci-*
> *ated in this culture—just sitting there, doing nothing . . . which is not*
> *doing nothing at all.—Connie*

Despite the fact that, in the past, the majority of both life models and artists were men, contemporary models agree that male nudes working with male artists incur the greatest social stigma. Today we are more accustomed to viewing nude women than nude men. Consider, for example, the U.S. film industry, which has long accepted full frontal nudity for female actors but still balks at similar male exposure. Ubiquitous media ensures that we encounter the young, naked female body often in daily life—when we are shopping, reading magazines, or simply making our way to school or work—so we have all grown accustomed to it. We perceive the nudity of males differently and less often. This is, of course, a reflection of power structures in society and

"the gaze." In our society, male power and dominance are reflected in the greater availability of female nudity. This is not to say that all female nudity is acceptable viewing; exposure of naked elderly bodies of either gender is socially unacceptable.

A man viewing male nudity is especially unacceptable, since male-male gazes raise the specter of male homosexuality—one of the least acceptable relationships in our society. A women looking at female nudity does not raise the same level of concern. Because our dominant gaze is masculine, we all look at female nudity through the male lens. Moreover, homosexuality between women is generally more accepted than homosexuality between men, partly because in a patriarchal society, women are considered less threatening than men. In addition, women are often viewed not as sexual agents themselves but instead as recipients of male sexuality. In dominant ideology, two women cannot have "real" sex, because there is no penis involved, so what they do together is of lesser concern.

> There is the perception that it is okay for a female to do, but it is not for a male. I feel that a lot. There are thousands of artists who have chosen women as someone to represent, and I think that a lot of people out there still have that in mind, that it is okay for women because they have seen that many times before. It's kind of weird for a male to be modeling nude.—Jonathan

INSIDE THE STUDIO

Inside the artist's studio, stigma management strategies must take into account the gendered nature of work sessions. Often, male and female models experience their sessions differently, and they may employ different strategies to manage stigma. This doesn't necessarily mean that one gender has a better or worse experience; a gendered experience is simply inevitable as long as people are gendered and as long as society defines and treats gender categories differently. When a man models, he is simultaneously and unavoidably a man, and how he experiences what he is doing as a life model, as well as the demands placed upon him, will necessarily be filtered through his gender.[3]

At the most basic level, our cultural preference for female nudity means that there is more life modeling work available to female models than to males in the contemporary United States. Most studios rely upon the female life model as the base or standard for their curricula and use male models only occasionally.

> Most artists want to do women. . . . [T]hey don't book a lot of men. The artists don't show up when [the model is] a male. So that is a little strange. I think most people would agree that women are just more beautiful than men.—Timothy

Art studios and schools remain, to a large extent, male-dominated institutions. Even so, the common assumption within the art studio that female bodies are simply more interesting and beautiful than male bodies is a bit surprising, particularly since life models routinely attempt to reject society's sexual scripts and often assert that to an artist, all bodies are equally valuable and interesting. Yet, by all accounts, a substantial majority—approximately 60 percent—of all life models in the Portland area are female, reflecting this gender bias.

Furthermore, although pay and studio conditions are virtually the same for male and female models, once in the studio, they do not have access to the same range of poses. Certain movements, gestures, and stances are relegated to males, while others are defined as essentially female.

> Men are different from women, and men have men roles, and females have female roles. It's a natural thing. It's not a sexist thing. And so women tend to take entirely different poses than men. . . . [O]ther than that, the process is pretty much the same. They show up, they work for the same people, [and they use] the same pads and stuff to sit on.—Karen

> Male models just have more angles; females, more curves. Just by the very nature of the female model you are going to have softer poses, where with male models you are going to have more angular poses.—Robert

In general, the poses favored by male models are more active while female poses are more passive. Active poses include what models describe as "heroic" stances, "working" stances, or "athletic" movements or gestures. Passive poses on the other hand, are assumed by sitting or reclining and exude a languid air. Male poses appear to challenge the gaze, and female poses welcome or attract the gaze. Life models explain that such gendered poses are both natural and "socially determined," reflecting the basic physical and social differences between men and women.

Physically, male and female bodies have different centers of gravity and different muscle and fat distributions. Thus, men and women, regardless of their fitness levels, will find different poses more comfortable and will differ in their ability to maintain particular poses over an extended period of time.

> A woman will pose herself differently because of the weight. The bulk of the breasts, [and] the thighs are usually larger. That means that something they would be comfortable with is something that I would be uncomfortable with, just because of strength or just the way that her body is proportioned. But I can be comfortable having my arm in a place where she cannot hold it physically as long as I can.—Jonathan

Socially, regardless of the body's physical ability to form or hold a pose, some poses are expected of male models and others of female models.

With male bodies, they tend to want more of an up-and-down, standing pose, maybe with twisting, bending, that sort of thing, sort of a Greek pose. With women, it's more with them laying down, for instance, lying down on your side, say in a fetal position, which is a popular pose for females everywhere.—James

The range of socially acceptable poses is narrower for male models than for female models. This is somewhat ironic, given our unquestionably male-dominated social structure, but not surprising: social scientists have long drawn attention to social interactions in which men's roles are more limited than women's. A little girl may be a "tomboy," but a boy will not be given similar freedom to display cross-gender traits. Women are allowed a broader range of emotional expression than men, who are still taught to avoid signs of "weakness" such as crying. A man who wants to be a stay-at-home dad or a child-care worker is still met with skepticism or even with suspicion, while women may display both nurturing and career orientations.[4] In life modeling, while more passive poses are the norm for women, female models nonetheless report that they do often break out of those poses and take more masculine ones.

I like to project a wider range of female expression. I like to show strength. I like to squat and be an animal, not just a leaf.—Connie

A female model taking an active or masculine pose does not call into question her femininity. Indeed, like the tomboy, she is likely to be encouraged and admired for her ability to "do what the boys do." Male models, however, do not feel free to adopt more feminine poses. A male model who assumes a more passive, female pose is likely to call into question his masculinity. Few male models take female poses of their own accord. On the rare occasion that a male model is asked by an artist to assume a female pose, such as lying in fetal position, he will be suspicious of the artist's motive, alert to the possibility that it might be sexual, not artistic.

It's harder for me to do a pose that I would frequently see a female in. And I do do them. And I have to keep reminding myself that there's nothing going on. They simply want to get a body pose—at least I think.—James

Some male models express frustration at feeling excluded from a wider range of poses simply because of their gender.

Sometimes I feel limited when I am posing. Sometimes I feel I can't do it because it is not right for a male to do it. A lot of people will think, "Oh, he's a pussy-foot." Why can't I do that? Why can a female be so masculine and not get a misconception? Why can a female be butch? Why can she pose like a man, and people will like it? Artists will think she is a strong person. But you know it is wrong for a male to be feminine. And I sometimes feel limited by that. Sometimes I worry that I am being too feminine.—Jonathan

The extent to which gendered restrictions on poses are imposed externally, by artists, or instead reflect models' internalized notions of gender propriety is difficult to establish. No model I interviewed reported having been overtly sanctioned for taking a gender-inappropriate pose. But perhaps they preemptively avoided poses that might make artists uncomfortable. In any case, there was no doubt that female life models felt a greater sense of latitude in their work than did their male counterparts.

OUTSIDE THE STUDIO

Life models try to anticipate how people outside of the art studio might judge them. Given the distinct possibility of being judged negatively, the models I spoke with were strategic about whom they decided to tell about their work. Most had told their families, although several had specifically kept silent with their parents, even though they were open with siblings or other family members. Many who did tell their parents about their work explained that their willingness to do so was related to the fact that they were already the "black sheep" of the family or already known for doing odd things, so the new information was just one more thing in a list of eccentricities that their parents had come to expect.

> My family doesn't have a problem with it. . . . I don't talk with them much. I have always been a different type of person. They just expect that kind of thing.—Timothy

> I do a lot of things that upset my mom, but she almost always comes around.—Tracey

When families were not accepting of a life model's work, it was usually because they assumed the work was really some form of sex work. Models thought that if the true nature of life modeling were understood, there would be fewer problems.

> My mother, she thought it was a great idea for me to do it. I know my mother noticed that I was quite inhibited as a younger person, and she thought it was good to be able to go there and to express myself. . . . My father, on the other hand, he disapproved. . . . Seeing that I am gay, and he isn't too comfortable about that, I think he sees it as a form of exhibitionism, that I would get off on it sexually.—Jonathan

While models generally accept that some family members cannot be told about their work, or may not be supportive, they expect to be able to talk to their friends and to receive their support. They realize that people might need to be eased into an understanding of life modeling. But if they cannot ultimately tell someone what they do, that person is not usually considered a real friend or kept as one. In fact, for some models, the disclosure of their work becomes a sort of friendship litmus test.

When I meet new friends, I usually wait a while before I tell them. . . . But, as far as friends go, frankly if they cannot handle that, they are not going to be a friend anymore.—Joan

I figure I am going to be right up front about it. They either come to terms with that aspect of me, or we're not going to work. Because I'm libel to do all kinds of weird things, and maybe this is just one of them.—Michael

Models were harsh judges of friends who had rejected them based upon their work. Such exfriends were considered ignorant, or as one model said, "*obviously low class.*"

All the life models I met expected their lovers or spouses to accept their career choice, even while they did not necessarily expect them to be comfortable with it. In other words, models wanted their lovers to understand their work and to appreciate life modeling as a legitimate artistic endeavor, but they realized that life modeling as legitimate work for "somebody" is very different from having your own partner nude in front of strangers. Most of the time, life models accepted that their lovers would feel some level of jealousy or discomfort and made managing that discomfort part of what they did in their intimate relationships. Most talk openly with their partners about their work.

Well, my wife . . . knows that this is where my interests and my life are, so she sort of looks upon me as—well, she doesn't particularly like the idea of me going around naked all over town.—Victor

If anyone has any kind of concern about is this an escort service disguised as modeling, or is this going to mean that you're not going to be faithful because you are with all these people in a semisensual setting, I invite them to come out. So I've had two of my intimate partners come and see what it's about.—Irene

Still, models were not always successful in calming their lovers' fears, and many reported having had relationships end either because a partner's jealously became overbearing or because a partner continued to misunderstand what life modeling was about. Remarkably, none of the models I interviewed said they had considered giving up life modeling for a lover.

Because for most life models modeling is only a part-time profession, most have other jobs with other employers and coworkers. Models do not tend to discuss their modeling work with these outsiders.

Coworkers? Forget it. It's two separate lives, modeling and then my normal life.—James

Such secrecy seems to be the norm regardless of where else the models may work, whether it be, as in the group I came to know, in a corporate law firm, a major computer software company, a college, or restaurant. The only

exception seemed to be if the model's other job was also within the art community. Models tend to assume that other people in the arts will understand and respect their life modeling work. Outside the art community, models fear shocked or negative reactions from coworkers.

While decisions models make about disclosing their work to family, lovers, and coworkers may seem predictable, their negotiations with strangers and new acquaintances are much more complicated. With strangers, the models I spoke with did not always want entirely to avoid the social stigma attached to their work. Many like to try to use and manipulate that stigma to their own advantage, rather than allowing themselves to become passive victims, struggling to cope with a burden.[5]

Men often used their liminal status as life models to gain access to the artistic community. In fact, ever since bohemian culture grew out of the artistic community in Paris, models have used their work as a point of entré into that culture. More often than women, men reported that their "regular" jobs were outside of the world of art and that modeling allowed them to enter an environment from which they would otherwise be excluded.

> This is a way for me to get back on stage. And it fulfills something that was missing, that's been missing in my life since she [Michael's daughter] was born. She's been the greatest thing in my life, but it makes a change in life, because you can't do those kind of things, especially if you have a full-time job. I can't go around chasing musical gigs, going to clubs to play until two o'clock in the morning, or do that kind of stuff that I could do before I had a kid. . . . So it's feeding into that need that was missing in my life.—Michael

> I work in a very structured environment. Everything is deadlines and within certain parameters, and the people I work with tend to be that way as well. And I find that being in art classes you find a lot of creative, artsy people, people that are much freer in their thinking and in what they like to think about. So, it's 180 degrees from what I normally do, and I enjoy that.—Robert

Although female models may seek entré to the artistic community through modeling, they are more likely also to have additional ties to that community. More useful to them is their ability to exploit their work as a "celebrity stigma," that is, to manipulate selected preexisting stereotypes of life models as bohemian, glamorous, seductive, and sultry.[6] This does not mean that the models themselves believe the stereotypes but that since the stereotypes exist, they believe they might as well use them to their own advantage. In this respect, they are like a biker who mimics the look of a Hells Angel to "cash in" on the romantic image of the motorcycle outlaw. Female life models strategically disclose their work in interactions with outsiders to provoke interest or envy.

I think that men are titillated, like, "Oh, what do you do?" "I'm an artist's model, a figure model." "Oh, you mean that you are just up there naked?" And I am like, "Yeah, I am." They are affected by it. It's not so much that I do it, as that I can do it.—Nancy

Because our cultural image of female life models is one of seduction and sex, female life models often find that the men they meet make assumptions about them sexually.

I have had men really believe, "Well, gosh, if she gets naked in front of all these people, she must be promiscuous, kinky. She must really love sex. She must be a sex fiend."—Rachel

Heterosexual men respond with desire and interest to a female model they assume to be sexually "kinky," different, or assertive. This interest may be either welcome or unwelcome by the female model, but it can certainly be used. Interest is the currency of intimate relationships, and translates easily into power. Because female strangers do not have the same positive response to male models whom they perceive to be kinky, and male life models do not fit dominant images of masculinity, this avenue of stigma exploitation is more limited for male models.

POWER AND VULNERABILITY

Our clothes protect us. When we think of a person being naked in a public setting, we think of that person as being vulnerable and in danger. Certainly, a naked person is in a weaker position than a clothed person in most situations. Thus, I was surprised to find that both male and female life models routinely speak of feeling powerful while modeling nude and describe their work as empowering.

For me there is definitely a sense of power because I know that I can direct the sensuality, not toward a sexual end, but towards having a high-quality experience.—Nancy

No, I don't feel vulnerable at all. I wish I could walk around naked more often, but I don't.—Leah

I think it's a big power thing. I always feel so much more confident after I have done it.—Jonathan

There are subtle differences in the way that male and female models describe the empowerment that comes from their work. Female models most often explain that modeling is empowering because, through life modeling, they had come to see themselves as attractive. Prior to life modeling, many of the

women I spoke with had doubted that others would find them attractive, but life modeling had taught them otherwise. This realization gave them greater confidence as models and in their lives generally.

> *I realized that it was an enormously healing job for me. . . . I had always known that I was attractive, but I guess I felt that, well, maybe I am wrong about that or that I am beautiful on the inside and that is what counts. . . . Now I don't have that lack of comfort being a model anymore. I have more emotional confidence. I can recognize that I am not the only person who thinks I am beautiful.—Joan*

> *They've [the artists] accepted my body, or perhaps they haven't, but at any rate, they want it. And sometimes there's that special moment when somebody actually draws you, and it just makes you look so extraordinarily beautiful, so you can't believe that's you. And some people actually see me that way. Wow, they see that.—Rachel*

In a male-dominated society, being attractive to men is synonymous with just being attractive, since men define the dominant ideology and aesthetic. Female models tend to define themselves as attractive when they think others define them as attractive; like other women, they have been taught that their self-worth is dependent on men finding them attractive and women envying them for their attractiveness to men. John Berger explains the plight of women as follows: "How she appears to others, and ultimately how she appears to men, is of crucial importance for what is normally thought of as the success of her life. Her own sense of being in herself is supplanted by a sense of being appreciated as herself by another."[7] Most of the female models I spoke with were heterosexual, but this same dynamic held true for lesbian and bisexual female models.

Male models, however, rarely mentioned the opinions of others as central to the power they gained through life modeling. In fact, if they did mention the opinions of others, it was to say that life modeling had helped them to reject those opinions. Modeling had made them like their own bodies more and made them realize they had good or strong bodies.

> *I always was comfortable with my body. . . . But now, instead of spending so much of my time worrying about how people are going to view me, I am not afraid of people anymore.—Charles*

> *I would call it acceptance of who you are and not caring so much [about what others think], just accepting that this is the way that you are. You are happy with it, you don't care. Of course maybe you want to be bigger, taller, or something like that. But it's not a big deal.—Donald*

It was also common for male models to tell me that they simply enjoyed being watched. They rarely tried to interpret this watching in the way that women

did. They did not assume that because they were being watched, the watchers found them attractive. Instead, they themselves enjoyed the experience of being watched and found it empowering.

> *It just gave me a sense of empowerment that I was the focus of their attention.—Jonathan*

> *I was thinking that there were tons of people just standing there watching.—Donald*

There seemed to be a general sense among male models that their bodies would be attractive, or acceptable, to women but that other men would be harsher judges or competitors. When male models did mention the reaction of others to their nudity, it was usually in reference to something a man had or had not done. Some men found life modeling empowering because they could be naked and not have to worry about other men becoming violent. Others spoke specifically about their concerns that men in the audience might find their penises too small or peculiar in some way and about how life modeling had helped them to realize that their penises were, in fact, quite normal.

> *It's safe. There is no sense that you're going to be attacked while you're making yourself vulnerable.—Eric*

> *If you're not circumcised, it's different than most of the people. Are people disgusted by what they see? Are they, are they really trying to look away but are forcing themselves to look? How do the other male students feel about it?—James*

SAFETY

The models I spoke with agreed that if modeling differed for men and women, it differed most markedly in how cautious a model needed to be in initiating a session with an unfamiliar artist: everyone agreed that women needed to be more careful. Female models did not express concern over modeling privately for women artists, but they would not work for an unfamiliar male artist without first checking him out, both by meeting and talking with him prior to any engagement and by calling local art studios for references. One particular studio in Portland, founded and run by a couple who are themselves both life models, seemed to be an especially trusted source of information on unfamiliar artists. Most women relied on their own gut reactions during initial meetings. If an artist seemed odd, the model would claim that she was booked and had no available time.

> *I never did sit for him. I met him downtown, and we went to the park. We took some pictures. He kept wanting me to put my strap down . . . I never worked for him.—Nancy*

I had seen the guy at [studio name] and in another open studio. I felt like I pretty much knew him . . . I talked to him a lot, and I kind of got his philosophy of stuff, and I knew that Tom [the owner of the studio] had recommended him.—Denise

In addition to their advance investigations, most of the women I spoke with had some form of backup protection when sitting for a male artist for the first time. Some took a male friend along, and others carried something that could serve as a weapon, such as a wrench. The specter of rape by an unknown man commands the attention of American women, even though the rape of a model by an artist is, statistically, much less likely to occur than are some other possible crimes—which a woman might also commit—such as robbery or fraud.[8] Oddly, none of the women I spoke with carried actual weapons, or even cell phones, despite their wide availability. Neither did any of them report ever actually having to use one of their "weapons."

Group sessions, and in particular classroom sessions, do not evoke the same safety concerns for women. Therefore, female models are often faced with a trade-off: private sessions have greater potential for a quality artistic experience, but also more potential for danger. Classroom sessions, because of the inexperienced artists and many distractions, have far less potential for a remarkable artistic experience, but they are also less potentially dangerous. Male and female models both recognize this dilemma for women.

Most women models are a lot more cautious about who they are going to pose for privately.—Connie

I'm big, and I'm male, and I just never think about my own safety like a woman who has been naked for a number of hours might feel as she walks out into the night.—Victor

With men, they will take a job because it is a job. They might be concerned about the intentions of the person, but they are more apt to take a job because it is there, and they need to work. Women are a lot more cautious. They hesitate, and they want more information before they take a job.—Jason

If a male model suspected sexual intent in a female artist, he might feel concerned but not *afraid*. However, male models did commonly express worry about initiating private sessions with unknown male artists. This concern seemed primarily about the potential sexual intentions of the artist and not about their own physical safety. They did not fear rape, but a socially awkward or uncomfortable situation. Many of the heterosexual male models I met went out of their way to assure me that they were not gay; they may have feared that artists would think they were gay and sexually available. This could be simple homophobia or a more complex fear that having been

stigmatized in one way by being a model, they would be stigmatized in another. They did not, in either case, express any concern over being forced into sexual activity.

GENDER AND EROTIC EXPERIENCE WHILE POSING

Researchers have found that most forms of public nudity are not experienced as erotic or sexually satisfying for the participants. People who strip at Mardi Gras parades, or moon, or streak, or visit nudist camps rarely report their experiences as sexually arousing.[9] I wondered if life models also experienced their nudity in a nonerotic way. The fact that they work to build and maintain boundaries between the sexual and the sensual in the art studio does not necessarily mean that modeling is not erotic for them; it just means that they must hide any erotic feelings. Yet, even after I had spent a lot of time with models, and they seemed to have accepted my motives as academic, I found that most were hesitant in discussing the possibility that they might experience sexual feelings while they worked.

> I can be very sensual and create very sensual performances on the modeling stand, but I want to make—I want to leave no question in anyone's mind where my boundaries are.—Irene

Neither men nor women said that sexual arousal was common during modeling. A few women reported that they never had erotic experiences when posing.

> No, no, it's not erotic. Sitting there freezing your buns off is not erotic. And being stiff as a board, I don't think so. And having to find something to think about for three hours, that's not erotic. . . . I've never been sexual with anyone I model for, except for the very first person I modeled for, when I was modeling clothed.—Rachel

Other women did experience posing erotically. Female models who reported experiencing sexual arousal while posing did not touch any specific body parts or focus on another person in the room but instead were aroused by their own fantasies and physical sensations.

> Sometimes you're up there, and you go, "Gee, this is an erotic pose." So sometimes the art model is sitting there getting really hot on this pose, you know. It's there. It's definitely there. When I'm sitting there for three hours with nothing to do, I think about it. Especially if I am dating somebody new.—Karen

> At times it's extremely erotic, undoubtedly erotic. And it can be erotic with women drawing and men drawing, I don't make a distinction there. And it can be erotic in a pleasant way and erotic in a not so pleasant way.

*[Some]times, it feels wonderful for me to be in my body and to be so pre-
sent in my body. For me, being very present in my body is a very erotic
activity. It's not like a whole session will be erotic and another won't be.
It's more like there will be this little wave. "Oh, well, ok." Then another
wave like, "Oh yeah, oh God." This one time, I was taking a long-term
pose, and he [the artist] would tape it, to make sure my arm was in the
right place after the break, and he came up to tape the pose, and it was the
most intense sexual thing I had ever experienced.*[10]*—Liz*

For most female models, erotic experience while posing is a combination of
physical sensation—a particular pose, the warmth of the studio—and a men-
tal or emotional response to that physical sensation.

*It is a very pleasant activity, usually because it is very warm. Usually
there are lots of lights, and so here you are naked and warm. It's really
lovely. And all the heat and the lights is sensual. Also, especially with ges-
ture poses, you can work up a sweat and feel your muscles strain, and I
really enjoy that.—Joan*

Male models often speak of female models' ability to experience erotic
feelings while modeling wistfully; they envied that perk of the job. Both male
and female models believed that women had a more erotic experience while
modeling.

*I've heard stories from my female model friends. They just have like crazy
erotic fantasies the whole time. This woman told me this story of this pose
she took that was painful, and she was having this crazy fantasy, and
there's some kind of relationship between pain and erotica. She was using
this pain in a psychological way, and she just said she almost, like, . . .
was able to complete the experience for herself in front of the class. It's def-
initely something a male could never consider doing.—Richard*

Unlike women, male models defined eroticism or arousal strictly in terms of
"using" or manipulating their genitalia, or penises, so that they could not
experience eroticism while working. An erection without the possibility of
satisfaction was simply a nuisance.

*No, no, I would think that would really interfere with what I was
doing. . . . I wouldn't be relaxed, and I think that would really ruin the
poses. If somebody is kind of tense, and I think that being excited would
be a form of being tense, they would probably have problems at some
point. Whatever their motivations were they would be inappropriate, and
they probably wouldn't be hired at some point.—Patrick*

*I try not to do that [because] I would be embarrassed. Once, in a sculp-
ture class, this woman was rolling clay and looking at me and shaping it*

[into] this big column with kind of a mushroom top. And she is looking at me, and she has got this silk top on . . . and I had to really . . . that was the hardest I worked, because I was participating on a higher plateau. I couldn't do anything. I felt like maybe a little fluid was coming out of me, and I was embarrassed.—Timothy

Since both sexual interactions with an artist and erections while posing are considered professionally unacceptable, there are few avenues left for erotic experience by male models. They do enjoy being looked at and often gain satisfaction or pleasure from that experience, but they do not define that pleasure in erotic terms. Instead, they tend to describe their experiences in more cognitive terms, less emotional and less sensual.

Just the way that I can see that they are really appreciating my body, and I think anybody would like that. I get an enjoyment in myself. I don't get excited in a way where I would get an erection. It is just more of a mental satisfaction.—Jonathan

EIGHT

"Michael"

ALTHOUGH I ALWAYS tried to meet models for the first time in a public set-ting such as a café, Michael was insistent that I come to his house. Since his divorce, Michael had shared custody of his daughter, and we were meeting on a school night. He lived in the hills just outside downtown Portland, and his home suggested a level of affluence that I had not otherwise encountered among area models. He met me at the door, a handsome man in his midforties, physically fit, and unusually tan for the middle of a drippy Oregon winter. We walked through the front hall to the living room, where Michael was having a glass of wine, and his daughter was searching for an escaped pet rabbit. As I sat down and organized my tape recorders and notebooks, I noticed that most of the walls around me were hung with photographs of Michael modeling nude.

Unabashedly self-absorbed, and admittedly vain about his appearance, Michael had come to life modeling via a failed attempt at fashion modeling.

> I had a photographer take some shots that I put together in a little thing and distributed around to see if I could get some interest along those lines [fashion modeling]. I have a day job, so I couldn't spend a lot of time with it. It takes a lot of time, and it takes a lot of effort. Takes a lot of contacts. And, you know, I just didn't have it, especially this late in my life.

Michael shifted his attention to life modeling some time later, after attend-ing one of Portland's "First Thursday" events. (On the first Thursday of each month, downtown-area art galleries stay open into the evening, offering food, wine, and music in an effort to stimulate public interest in, and ultimately sales of, artwork.) At one gallery, Michael noticed a sign from a photographer looking for nude models.

> I thought, hmm, that sounds interesting. Why not? And I just had a kick. It was so much fun. We went out to the coast for a weekend, and actually some of the photographs as you came in, on the wall, were taken during

*that shoot. And one of them got published. . . . Then, I thought, well, you
know, while I still got a body to show off, why don't I try the art thing, you
know? So I made an advertisement using the photograph that was pub-
lished, and I stuck it up in some of the schools around here, thinking that
artists might contact me.*

Nobody did contact Michael, however. In fact, a whole year went by before
Michael was offered a life modeling job. By luck, that job was at a private stu-
dio known in the area for supporting and promoting life models, and Michael
was able to make enough new contacts there that he afterward began to get
regular calls for work. That had been two years earlier, and Michael had been
modeling ever since. He scheduled his modeling sessions around his full-time
job and around the hours that he had his daughter. He did not take model-
ing jobs on the evenings or weekends when they were together. As a result,
he usually sits for four or five sessions a month.

 The photography around Michael's home reflected his preferences in
modeling. He was the only model I met who preferred working with photog-
raphers. While most of the life models I spoke with refused to work with pho-
tographers at all, claiming that photography was more sexual and less artistic
than other media, Michael liked many of the things about photography that
were off-putting to other models. He thought nude photography could be sex-
ually titillating, and he enjoyed it as such.

*The nude photography I've done has been semierotic photography, and
that, for a whole host of reasons, tends to be a lot more fun.*

Michael also enjoyed expressing himself erotically when posing for pho-
tographs—something that most male models told me they were incapable
of doing.

*I always bring ideas along. I have a head for erotic ideas, and I get to
express those in front of the camera. And the photographers like that,
because then they don't have to think so much. So, in a way, you kind of
live out a fantasy sometimes, and that's fun. That's just pure enjoyment.*

Michael's erotic expression did not include getting erections. Like the other
male models I interviewed, he said that erections were pretty much out of the
question while modeling.

*The true test came one day when. . . . We pulled the podium out from the
wall, so I was working in the round. I was surrounded by twelve females.
I mean, I'm the only male in the whole place. If anything was going to
happen, it was going to happen then. It suddenly dawned on me, what I
was doing. And I couldn't help but get a smile on my face, because I
thought, "Shit, Michael!" I mean, most guys would die to be here. But
I've never had an erection.*

Talking with Michael, I was struck by how comfortable he was talking about his body and his sexuality. Usually, models were slightly uncomfortable discussing the erotic potential of their work, even after we had developed a respectful rapport. Michael, however, seemed to relish talking about the sexual aspects of modeling. He laughed at himself and at what he saw as our culture's absurd standards of sexual conduct. He made it clear that if he could get an erection while posing, he would like to, so I asked him why he thought there was such a taboo on models' erections.

It's all stupid as far as I'm concerned. Western society's so hung up on the whole idea. It always amazes me, and unfortunately, I live in that society. We all have to put up with it.

Michael preferred modeling for photography to modeling for painting or sculpture not only because he though it was more interesting in a sexual way but also because he considered it easier work. He particularly liked the speed of photography, the very characteristic that made it unappealing to other life models. A self-described "casual" life model, rather than a professional, Michael was less concerned with abstract issues of artistic creation and objectification and more concerned with whether or not he was enjoying himself.

Well, the poses are real quick. I mean, you've only got the shutter speed to worry about. You can go through a whole series of poses in a real short period of time, and the whole time the shutter's clicking. And then the photographer picks the ones that he likes. So you don't have to be quite so conscious about the pose itself, because you can get a whole lot of different poses out of a series of real bad things.

Photography jobs are more scarce than life drawing or painting classes, so Michael did sometimes model for life drawing sessions as well. He found this type of life modeling more difficult mentally, because he had to plan and organize his poses consciously. Modeling for drawing sessions was also more challenging physically.

It's a lot more painful physically. I mean, it's hard. It's a lot more difficult work. People don't realize if you have to stand in one spot for thirty minutes without moving, you find little muscles that you never knew you had before. And they make themselves very noticeable.

After talking with Michael several times and watching him work in local studios and schools, it was clear to me that life modeling was Michael's way of playing. Unlike many models who claimed artistic or spiritual motives for their involvement in life modeling, Michael was simply having fun. He was an attorney with a local law firm, and didn't need the money he earned modeling. In fact, he would model for free if an artist couldn't afford to pay him. None of the men or women who considered themselves professional life models told me

that they would be willing to pose for free, although some had traded modeling for painting or drawing lessons. At the end of my research, Michael remained the only model I interviewed for whom modeling was strictly a hobby, done for its own intrinsic pleasure. Most other models needed the income they earned from modeling, and many also spoke of themselves as artists dedicated to the production and advancement of art. Even those who found in modeling a path to personal growth did not describe the work as recreation, the way that Michael did.

I spent a lot of time trying to understand why Michael had chosen this particular hobby. It seemed to me that there were many other, easier ways to play or have fun. Michael had no financial need to model, and, in fact, if his colleagues discovered his life modeling work, his entire career might be in jeopardy. He said that his law firm tended to be quite conservative and that it was important to them that they project a conservative public image. Why then, modeling? Michael told me that he, too, had felt a need to figure out why he was doing it and that he had recently made himself sit down to sort through his thoughts. What he came up with was a surprisingly frank realization:

> It's not a big sexual thing, because it isn't. I'm always thinking ahead to the next pose. What pose am I going to strike? What angle do I want them to look at? Am I going to be comfortable for fifteen minutes doing it or thirty minutes doing it? So, I mean, there are a whole host of things going through my mind other than sex. So, I was thinking, well, is it just 'cause I'm kind of an exhibitionist? And, honestly, that's probably it.

In saying "exhibitionist," Michael was actually moving away from the sexual aspect of his work, to his enjoyment of the attention, the performance. He liked being on stage, exhibiting himself. In short, he liked to be noticed. The son of a small-town doctor, he had been well known as a child. He went to a small school in his small town, where he had stood out in the school band and theater. The desire to be in the spotlight had remained with him as an adult. Life modeling represented a compromise for him, between what he would ideally be doing and what he felt that he could practically and responsibly do with a young child.

> I don't have time to play my music any more, but I miss being up on stage a whole lot. . . . If a genie appeared and said, "Do the three wishes," the first thing I would wish for is to be a professional musician. I just love being on stage. There's no feeling like it in the world, and this is a way for me to get back on stage.

Still, I asked Michael if there might be other ways of getting on stage that wouldn't require nudity or secrecy from coworkers and that were not so physically rigorous. He admitted that he had been wondering the same thing.

Lots of times, recently, I have not felt like doing it, you know. It comes up to the date where I'm supposed to model, and I think, "Oh jeez, I've got to do this again." I don't want to be a circus act again. You know, 'cause you kind of feel like that sometimes. And, you feel like maybe it's a little demeaning, and maybe I shouldn't really be doing it. All these things go through your mind. And so I find myself sometimes kind of dreading it. But the thing's set up. I'm not going to let the people down. I'm going to show up. So, I get over there, and I get into it, and my mind starts clicking on the poses. And I think, well, you know, this isn't so bad. Hell, by the end of three hours, I don't want to put my clothes back on. I feel so great. And I'm thinking, "Oh God, I can't wait to do this again."

Unlike other life models, Michael made no effort to couch his life modeling in professional terms. Although he wanted his modeling to be well received and tried hard to do a good job, he did not see himself as a long-term or career model. He participated in the meetings of the local life modeling guild because he enjoyed them, not because he felt compelled to advance the cause or conditions of life models. He had never personally had a bad experience modeling. On the contrary, he told me that the artists he worked for had always been respectful and appreciative of his modeling. As a hobbyist, rather than career model, if modeling became unpleasant, he would simply stop doing it.

Life models typically stiffened if I proposed a link between their work and that of professional strippers. Not Michael. Michael said that he had considered stripping and still might try it, "just for kicks," but that his job as an attorney was completely incompatible with stripping. He would lose his position in the firm if anyone discovered that he'd tried stripping. He also thought that he wouldn't like the late hours strippers must keep or what he imagined to be the typical clientele of strip clubs.

I'll have to admit I've been to some stripper bars, and I've often thought, you know, "I wonder if I can do that?" And I know that I could do it. I could get up there and display myself like that. Although I'm afraid the clientele would be a little bit not what I am looking for.

Michael's concern with clientele suggested a second, albeit less well articulated, motive for his life modeling. He enjoyed associating with artists and being able to participate in a more bohemian culture than that dominant at his law office. In this respect, he was actually quite similar to the other male models I interviewed, who often used modeling as a point of entré into the local art subculture.

Still, for Michael, vanity trumped desire for affiliation. He said he would probably only model as long as he felt he had a body "worth showing off." He knew that studios might welcome a less than perfect, aging body, but he was not sure that he wanted to provide it.

Like I said, it's just vanity. You know, I may not want to do it when I start bagging out too much. It just might not be something I feel that much comfort doing after a while. We'll wait and see when I get there. So far, I work out a lot, keep myself in pretty good shape, so I feel good about myself right now. And we'll see what happens later down the line when I can't forestall age anymore.

NINE

"Irene"

IRENE IS A MARKETER of artists and the arts. At least that is where she sees herself in a few years, perhaps as the owner of a gallery or studio workshop. Forty years old and single mother of a toddler, she is strategic about her goals. She is like a life model with an MBA: she caries a portfolio of her work, which includes photos of herself modeling; she maintains an organized mailing list of her "clients"; and she passes out business cards with a local "studio" address and an "office" number in New York City. When I tried dialing the New York number, there was no answer.

Like many life models, Irene was introduced to her work while taking studio art classes in college. Students in her class were required to attend evening life drawing sessions. At one of them, the scheduled model failed to show up, and the group decided that, rather than lose the evening, one of them would model. Irene volunteered. Later, she modeled several times again under similar circumstances. Then after college, she moved away from her home state and from modeling.

Years later, she returned to Portland, "took stock of her situation," and realized that she wanted to reenter the local artistic community.

> I was coming back home and not really being a part of an artistic community here and lamenting that fact. I had several close friends that are artists, but beyond that I was not really linked to this community. I was an outside observer. And so I was thinking of ways that I could get involved, you know, volunteer work and taking classes, and going to community drawing sessions, all of which I've done.

Classes and community drawing sessions, however, did not provide Irene with a sufficiently intimate link to the community, so she returned to life modeling.

> [It] occurred to me that I would like to model, because I realized that it gives the potential for a very intimate view into different teaching styles

97

and the potential for me to learn something, the potential to work in dia-
logue with instructors, who are often practicing professional artists in the
community as well, and to meet other people. I found that very inspiring,
because I paint and draw as well. And to meet other artists who are doing
the same is very inspiring to me.

Irene's motivation to become an art community insider was not only
artistic—because she liked to paint and draw—but also as she said, "merce-
nary." She thought she might be able to make a living marketing other peo-
ple's artwork, so she needed to know the local arts scene and the players, as
well as to become known to them herself.

I probably intend to model for a long, long time, 'til I'm old, because I
enjoy it, but my path and my livelihood I see as something different, but
linked, which is marketing other people's artwork, so I usually define
myself in terms of that livelihood.

I met Irene two years after her return to modeling, when she was model-
ing anywhere between fifteen and thirty hours a week—an exceptionally
busy schedule for a Portland area model. She attributed her busy schedule to
her own marketing and organizational skills. She kept a mailing list of artists
and teachers for whom she had worked and periodically sent them mailings
updating them on her address and contact information. Her fliers included a
graphic rendition or photograph of herself, clothed, so that artists could recall
what she looked like: tall and very thin, with pale skin and jet-black hair that
swung below her shoulders. Her fliers did not include nude photographs. Dur-
ing working hours, she carried her portfolio with the nude poses and was
happy to show it to prospective new clients as well as provide them with a list
of references for her modeling. Twice a year, she hosted what she called "an
invitational": she rented or borrowed a studio space in town, invited all of her
clients, provided food and drink, and offered two hours of free modeling. Typ-
ically, she spent an hour at these gatherings nude and an hour in costumes
that she borrowed from local shops or theaters.

Irene had a very practical perspective on her work. More than most models
I met, she considered what was needed from a model from the point of view of
the artist. Her first rule for good modeling was punctuality. Second, she thought
models should be prompt about incorporating artists' directives into their poses.

Divorce yourself from the ego part of it, view it as a craft, view it as the-
ater to the extent that you want to elicit that chemistry between the artist
and the model and the teacher in a professional way. You need to get the
most poetic, inspirational poses that are possible.

She thought a model willing to reach for the limits of his or her capabilities
was the one who stood out.

Someone who puts an aspect of poetry into their poses, i.e., a little bit more gymnastics, a sense of grace or strength or gymnastic ability. Whatever they're known for or whatever they feel like going to, but going a little bit beyond the comfort level of just parking and sitting on the modeling stand in a fairly straightforward pose.

Irene also cared a great deal about "professionalism." She had given considerable thought to her role in the studio and, in particular, to establishing her professional boundaries. She was adamant about her professional image. In fact, she was so concerned about her conduct as a model that she would not cancel a session at the last minute even if she was ill.

I had the stomach flu and had to excuse myself every twenty minutes to go throw up. To not show up would be to leave the class in a lurch, and I realize how disappointing that is to have to draw a marble vase for two hours when the model doesn't show up.

Unlike most models who decided what poses to assume either shortly before a session or during the session itself, Irene had developed a system to ensure that she offered artists a variety of poses without repetition. She organized the poses in her portfolio into what she called a "series." Before a session, she would memorize the list of poses, and afterward she made notes to remind herself which series she had performed for a particular group of artists. The next time she worked for them, she would assume the poses in a different series so that the artists were seeing something new each time she modeled.

Irene had an equally prescribed plan for dealing with her own mind during poses. Like most models, she found it necessary to "remove" herself mentally from longer poses, in order to tolerate the pain without moving. Unlike most models, however, she had developed a systematic procedure for "going away," which, she said, allowed her to minimize her pain without compromising the integrity of her pose.

I set up my body, go through the breathing exercises, recheck my body, and then go away. And I'll come back, you know, every twenty minutes or so, fifteen minutes or so, to check myself and make sure I'm okay. And I have that cycle that I'll go through. If I have a forty-five minute pose, there will probably be two or three cycles where I'll just continue to do those cycles over and over. Check myself, breathe, daydream, go into meditation; check myself, breathe, go into meditation. And that continues pretty systematically.

Irene was skeptical, she said, of "new-agey stuff," but the meditating she did while modeling was only one of several pain management techniques essential to her work.

I do about an hour of yoga every morning. If I didn't do that, I would be in a lot of chronic pain right now. Modeling is very hard on the body. It's just very wearing on the body. What you're doing is you are holding a pose that is asymmetrical and is not equal, a state of dis-equilibrium. You're holding it for so long that your body system is beginning to think that it is equilibrium, so when you straighten up and walk throughout the normal course of the day, your body thinks you are in a state of dis-equilibrium. I go to an osteopath regularly. I have regular massage. If I don't do those things, I will quickly lose my equilibrium. I will become dizzy, and my ears will lose their equilibrium. I'll have to sleep sitting up, and go to an osteopath several times. And that is what modeling does to my body.

Because modeling, for Irene, was a stepping stone to a business career in the arts, she cared less about immediate payment than about other, less tangible rewards the work might bring—like an expanded circle of friendship within the artistic community.

A very small part of the payback for me in modeling is monetary. That's an exchange that most of us in society feel good with. And so that's fine. I accept that. That's the standard mode of exchange.

Sometimes, she would barter or trade modeling for artwork or for art classes for herself. According to Irene, barter was a way of inserting herself into the artist's consciousness and inner circle of friendships. For most models, payment was based on the model's performance, not on who was witness to the performance. But Irene offered a sliding pay scale to artists, adjusted according to whom she was modeling for and whether or not the artist was a new client. No other model reported offering "introductory" or reduced rates to different clients. She charged more for groups meeting in private studios, under the assumption that all the artists would be sharing the cost of the model. She charged her highest rates, twenty-five dollars an hour, for commercial photographers, making a distinction between them and photographers she considered more artistic, whose sessions she would "want to make as cost friendly as possible." She provided each of her clients with a handout outlining her particular skills as a model and her payment plan.

I keep it at ten dollars an hour, because any more for artists who are not always very affluent is a lot. It would be too much money, and that would defeat the purpose of why I do it. If I really appreciate or admire their art-work, I'd rather work with them to find out how to make it possible for them to have a private model for at least a few hours. Part of how I do that is that any college students, I charge eight dollars an hour for the first three-hour session. And for the initial session, also, the first hour I don't charge for. The reason I do that, is that when you go into an individual artist's studio or if you're doing a group that you've never worked with as

a group before, there's a period of time that I have found takes about an hour to, you know, find out where the bathroom is, to talk to people, until everybody feels comfortable. . . . If some group got together and they wanted to say, "Could you come over to so-and-so's studio? There's five of us. We'd like to hire you for three hours." That would be fifteen.

When I asked Irene why she continued to model, now that she had established herself fairly well within the local art community, she explained that she would continue modeling as long as she enjoyed it and as long as it provided new contacts and moved her in the direction of her goals.

I think there's no limit to networking with people who are poetic by their very nature. That, for me, is worth an incredibly large sum of money. I don't think there's a limit to that. I continually meet new, interesting people that feed my own sense of creativity and that—whether it's organizing a new community drawing session or getting together to talk about their next project or having someone specific to see at a first Thursday gallery, or whatever—that's a really valuable thing to me.

TEN

Being Present

Getting Good at It

The paradox about modeling is that while it is regarded as unskilled work (proof being its poor pay and amateur practitioners) it is also, as all artists will tell you, a gift, and the "good model" a fact.
—Borzello, *The Artist's Model*, 31

FROM WHIMSY TO INTENTION

WHETHER A LIFE MODEL had been introduced to the work through an art class or by a friend, most reported that they had tried modeling for the first time on a whim. They wanted to make some quick cash, help out an artist friend, or test their own sense of confidence. Nobody had dreamed of becoming a life model as a child, and few had given any thought at all to what exactly a life model did before having to do it themselves.

> *I didn't know how to pose. They [the school that hired him] didn't give me any information. There is no printed information. Nothing. All I knew was I wasn't going to have my clothes on. That was it.—James*

After their first modeling session, and discovering that they enjoyed the experience, most life models took it upon themselves to learn about their work. There are no schools or classes to teach models what to do, no guidebooks available,[1] and, since models work alone, there is little opportunity to ask other life models for advice. Some models are able to conjure images of models they have seen, if they ever took a life drawing class; some are given tips from the artist. In the absence of any formal or structured training, though, most models told me that they had gone to art museums or libraries to study classic paintings and sculptures.

I have seen a lot of Michelangelo, a lot of classic sculpture, a lot of classic paintings. I just kind of had it in the back of my mind that that was probably what people wanted to see when they were trying to draw.—Michael

Looking at pictures, however, provides only limited information. Because pictures are two dimensional, they give little sense of what an entire body is doing. Moreover, the human figure is often distorted in art so that it is not always clear how a real person might position him or herself to look like a body in a picture or a statue. Finally, a pose that looks graceful on one body, with individual proportions, might look clumsy or awkward on another. So it is primarily through on-the-job experience that models learn how to model. It is a gradual process, and a very intentional one, entirely different from the haphazard process that may have brought the model to the studio in the first place. Some find the process too difficult and give up after only one or two sessions. Others continue, striving to become, through hard work and practice, a good or even exceptional model.

THE "GOOD" LIFE MODEL

Contemporary life models, I found, have strong opinions about what constitutes quality modeling. All models are not equal, they insist: the ability to stand calmly naked before a group of strangers is a necessary, but insufficient, trait for a good model. Other things are more important. And though models receive no formal training and work in relative isolation, they generally agree on what those things are.

BEING PROMPT, BEING PREPARED

Historically, according to art historian Frances Borzello, the "most important aspect of the models' professionalism was felt to be punctuality."[2] To a certain extent, this remains true today. A good deal of preparation goes into setting up for any life drawing, painting, or sculpting session. Materials have to be collected and rooms scheduled. Students in a school setting may spend several class sessions working up to a single life class. If a scheduled model fails to appear, or fails to appear on time, it means that all this work has been in vain.

Throughout the course of my research, I heard artists speak of life models in less than flattering terms. Models were "flakey," artists said, as if they lacked responsibility or maturity. Yet I found that models were not at all casual about appearing for sessions or about appearing on time. Models liked being able to choose when and where they worked, but once they had scheduled a sitting, they were exceptionally conscientious. They were equally conscientious about their interviews with me, although I did not pay them for

their time, and they did not feel any personal obligation to me. When I pointed this out, they explained that appearing promptly was the mark of a professional model and a point of pride. They would rather go to a session sick or miserable than appear unprofessional and inferior.

> *One time, I did have to model right after this man I loved dearly broke up with me, just hours before I had this modeling session. And I couldn't just not show up. It just is unethical.—Rachel*

A good model not only arrives on time but also arrives prepared. Preparation seems to fall into two categories: physical and mental. Models differ in the emphasis they place on each of the two types of preparation.

Physical preparation would include both activities adopted on a long-term, daily basis, as well as certain physical preparations made immediately prior to a modeling session. For some, a career in life modeling meant long-term changes in lifestyle. Models told me that since they had begun work as life models, they had learned to set aside time every day to exercise, do yoga, or meditate. Many also reported heightened consciousness about what and how much food they ate. These long-term lifestyle changes help models to cope with the physical demands and discomforts of posing.

> *I realized that it was important to do aerobic activity and to stretch and use the muscles, because if you are sitting in this atrophied state for a long time, it's important to get oxygen running through your body.—Irene*

Immediately prior to a scheduled session some male models liked to visit the gym or lift weights.

> *I do some exercises, kind of pump my muscles up a little bit, do some push ups and maybe some sit ups or something like that, just so muscle definition is a little bit better. And I'll go take a shower and then put some oil on my body, so my skin looks good. It takes about an hour just getting ready.—Michael*

Female models were typically less concerned with muscle definition, but many would still exercise immediately prior to a session to loosen muscles or improve appearance.

> *I like to ride my bike to model. I like to get there and be really flushed and have a rush of energy flowing through me from riding really hard.—Leah*

Both men and women also had to take care of many little physical details just prior to a sitting, such as fastening up long hair so that it did not obscure the neck or shoulders, removing jewelry, and showering to eliminate any other distractions.

I think a lot of models try to take care of any distracting elements. Like the unwanted things—like that little piece of toilet paper—it doesn't take much, just a speck will undermine your whole thing.—Jason

I have a few body piercings, and I always take them out. I think I would hate it if I had a life model come in with pierced tits. Because I know that part of the reason why I have pierced nipples is because of the focus it attracts, and I would not like to have that metallic focus on a nude body. I would want to draw a body as plain and simple as it can be. I don't think it is something that the artists should have to unknowingly focus on.—Jonathan

Women, if they are menstruating, must tend to the details of using a tampon and hiding the string. Finally, both men and women remove any clothing that might leave indentations on their skin, such as elastic sleeves or waistbands.

Mental preparations include activities that the models I met described as meditating or "becoming centered."

I think about it a few nights ahead and say, "Yes, I'm going to be able to give a battery of poses that work out well." Maybe do a little meditation. Promise myself that I'm not going to get into any poses that hurt so much—that sort of thing.—Russell

That is the mental aspect. I need to be completely with me that day if I am going to do it. . . . I need to put myself in the mindset.—Charles

Mental preparations also encompass intellectual planning for a session. Over the course of a three-hour studio sitting, a model may assume as many as twenty-five different poses of varying lengths and difficulties. It is not acceptable to repeat a pose. And if there are to be repeated sessions with the same artist or group of artists, the model must try to avoid repetition from session to session. For this reason, models agree that some planning is necessary so that they do not falter or hesitate between poses. Some models liked to practice a series of poses the day before a session; some wrote out specific lists of poses and the sequence in which they planned to assume them. Others would just review a general plan in their head before arriving at the art studio. For all, it is a point of professional pride to move smoothly from one pose to the next. It was also a matter of practical importance, since some poses cannot be maintained for very long. A model would plan the most difficult poses for the shortest sets—usually gestures at the beginning of the session—and the less demanding poses for sets that might last longer or come later, when the model was more tired. An ill-prepared model might accidentally assume a pose that he or she could not maintain or that was unbearably painful.

If you don't think about what you're going to be doing, that class is going to get very tired of you very quickly.—Irene

Figuring out what pose to get into and figuring out what poses you can keep for ten minutes versus what poses you can keep for half an hour. What pose you can do for one minute and that sort of thing. That was much more of a challenge than the naked part.—Connie

I did this one pose. It was stupid. My head was posed at a right angle, 180 degrees, and I had a pinched nerve I didn't know about, and I complicated it. I think it was a 240–hour pose. It took two-and-a-half months. So I did this pose two days a week, for four hours, and that was really dumb of me. I was foolish that time, and that was pretty hard. [That] should have been a five-minute pose.—Emily

KEEPING IT INTERESTING

Renoir is said to have used his servants as models, because he didn't like the predictable poses of professional models.[3] Contemporary models agree that there are better and worse ways to pose and that a good model distinguishes between the two. In some cases, of course, the model may have little say in what pose she or he assumes—the artist already has a particular stance in mind. Most often, however, the model has some latitude in selecting a pose. An artist or teacher may, for instance, request a reclining pose, but *which* reclining pose is left up to the model. In other sessions, the entire repertoire of poses is left up to the model. Since models usually do not know which way a session will be structured, they must always prepare as if the entire session's poses were up to them.

In a typical studio session, lasting about three hours, the mental and physical demands on a model are considerable. There are a lot of poses to keep track of, and three hours is a long time to "stay in character" or maintain a professional façade with all eyes on you. One studio in Portland told me that when they hired life models, they specifically looked for people with some theatrical experience, since it made them better performers on the stand. Models, too, often refer to what they do during a session as a "performance."

When a model is modeling, it can be very much like a performance. [Models] can take animal poses, dance poses. They can look like statues that you've seen in art history, and the model is definitely on stage and giving a performance.—Victor

Models explained to me that a good modeling session was one that inspired good art. In saying so, however, they were not usually referring to the tangible material output or artwork produced in the session but to something more ephemeral: the artist's sense of inspiration or interest and the chemistry between artist and model.

I think that what makes a good model, besides the professional aspects of knowing what you are doing, is how you engage the artist. It's being able to be animated enough while you are being so still that you are provoking a response.—Emily

Although it was not always possible for models to say what created this desired sense of energy, inspiration, or chemistry, they did name some practical elements that went into creating an interesting pose. First, they said, an interesting pose should show what they called "movement," even though the model's body was not moving. Instead, the model should try to freeze his body as if in midmotion. Often, this meant shifting the body's weight so that it was unevenly distributed. For example, most of the body's weight might be supported by the right leg, while the left knee was slightly bent. Alternately, the legs and hips might face in one direction, while the shoulders and head face in another direction, in a classic "contrapposto" pose.

I always try to make sure that I'm twisting in some way, moving in some way. There's usually an imbalance. An imbalanced pose is where there is weight on a particular part of the body, where you can emphasize that part of the body. You're not just static.—Rachel

Just sitting down would be a really boring pose. Artists like to have a little contrapposto, which is unbalanced, twisted . . . get the shoulders in different positions than the pelvic cage.—Karen

Second, interesting poses bring certain muscle groups or skeletal features into high relief.

Variations in weight or twist usually show off muscles in relief because they have to start working. All of a sudden this is contracting and this is extending and an artist has a dynamic thing to draw.—Liz

Which body part a model decided to feature depended on the model's body type. Very thin models usually chose to show off skeletal features or their backs, because backs are often relatively undefined on other body types. Muscular models often selected particular large muscle groups to feature, such as in the shoulders or legs. And, over time, many models developed what they considered to be a signature style.

They call me up and say, "We are doing the back tonight, and you have a great back," or, "We are doing this anatomy class on the back."—Susan

Little by little, I just sort of developed a style of my own that is now recognizable as mine—certain signature poses.—Nancy

My style would be poses that incorporate inner psychological expression through the gestures of my pose and my face. Most art models don't get involved to that degree.—Jason

Third, a good pose offers a satisfying view to all artists in the room. This becomes more difficult, the more artists that are present. If there are artists all around the model, the model must face different directions for different poses, so that each artist gets a variety of views.

I try and do something that I know is going to look good for everybody. I try to make sure that one side of the room isn't being ignored. Like I'm not turning my back to them over and over and over again.—Tracey

Let's say I've got to do fifteen one-minute poses. That's a lot of different poses to think of, you know, and you have to make sure one area of the room doesn't get the same side of your body and that each person doesn't look at only your side or your profile.—Emily

Finally, attitude is an essential element in an interesting pose. A model needs to be engaged in her own poses. According to models, if they are bored, their poses will also be boring.

The one time I felt like I did a bad job was when I felt like I was doing gesture poses by rote, ones that maybe I had seen before or done before.—Denise

DEALING WITH PAIN

Human beings, even when supposedly sitting still, are rarely actually still or motionless. Usually, we will shift our body weight slightly every few minutes or even seconds, absent-mindedly bouncing a foot, scratching, yawning, rubbing our eyes, or moving our fingers. Many times during my research, I tried to hold completely still for an extended period of time, just to see what it was like. What I discovered was that it hurt. Any pose, held frozen for any length of time, becomes extraordinarily painful to maintain. Pain and pain management are constant challenges for life models.

People on the outside underestimate just how physically demanding modeling is. You can really hurt yourself.—Eric

You have to be able to withstand the nagging pain that creeps up as the pose goes on and be able to pass through that.—Irene

When telling me about their experiences with pain, models frequently referred to "losing a leg," or "losing a foot," which happened when a model inadvertently assumed a pose that limited the blood supply to an appendage, so that it subsequently "fell asleep." During a pose, they could not "shake it out" or move around to restore feeling, and they had to take care when they eventually broke the pose, so that they did not fall down and risk real injury. Joints were problematic, too, especially in cold art studios. Studios tend to be large, in order to accommodate groups and all of their equipment, and still

offer a distanced perspective of the model. They are sometimes open to the outside, since paint fumes can be noxious. They are, therefore, drafty and cold. Even if the life model is given a space heater, the joints tend to stiffen, limbs go numb, and pain takes over the body. Many models who could have found more work, limited themselves to part time because of the pain.

Your body can't take more. . . . I wouldn't want to do more than five sessions in a week. If that many. Because you start kinking. It's really not natural to be awake and not moving.—Russell

It's hard on your body after a while. I've been modeling for quite a few years, and I'm getting older now. God, I've made myself so miserable when half of my body would be numb for the next thirty minutes of the session, and I would hurt for two days afterwards. I see so many new models do that, and I say, "Oh, you're going to change after a couple of years."—Rachel

I was surprised to learn that for many life models the work had lead to chronic, long-term pain or disability. Most often, they complained of pinched nerves and back trouble.

Life-size sculpture poses or life size paintings tend to be the longest, and they can go on for three to four months of the same pose, maybe four three-hour sessions a week. That's real discipline. And your body starts wearing in certain joints and things. I have actually damaged my lower back modeling long-term figure sculpture poses in New York.—Jason

In order to endure long stretches of pain while posing, models employed a number of pain-management techniques. Often these techniques involved patterned or rhythmic breathing, similar to the breathing exercises used for pain management in other stressful settings, such as childbirth.

You can think about breathing up and down your spine, or sort of circular into the top of your head and through the back and out your mouth. It's a yoga breath.—Natalie

Most pain management techniques also involved an attempt to distract the model's mind. This might mean occupying the mind with some unrelated thought, mentally rehearsing songs or conversations, counting, or performing meditation exercises.

Here is what I do: I almost always have a song playing in my mind. I will sit there and listen to the song. Sometimes I attempt to change the song. And I hope like hell it's not just a fragment of a song that is playing again, and again, and again.—Charles

Well, for a long time, I used to make my grocery list. Or remodel my living room, or else think about my newest lover. After time, I have learned

to meditate and you know, just leave my body. It's really a spiritual thing. Now I'm a Buddhist, and now what I do is chant. I envision all these wonderful things that I want in my life, which has really been working well for me.—Rachel

Meditation and distraction are never complete, however, because models must not lose control of their bodies. If models were completely entranced, a foot might wander, an arm or torso, sag. This, of course, is unacceptable. Most models told me that they learned to "go away" and then "come back" every once in a while, just to check in on all of their body parts. This allowed them to make sure they had not slipped or moved and also to discern if any body part was falling asleep or becoming numb. This sort of body check was necessarily brief, however, or else the model might get trapped by the pain of the pose.

For short poses, I remain very present. I will check my body periodically to memorize where my body is and check to make sure that my muscles are in the same position. That if this muscle was relaxed, it's still relaxed. If my arm is up here, then it's still up here. . . . Now a really long pose, like a nine-hour pose, I set up my body, go through the breathing exercises, recheck my body, and then go away. And I'll come back every fifteen minutes or so to check myself and make sure I'm okay. But I really do go away, because if you remain present that long, you are going to feel a lot of pain.—Irene

While all life models find ways of managing pain, their work is rarely, if ever, a painless experience. Good models do not move or break poses, no matter how painful. They believe the pain must be endured, and the body held still.

There are different ways to deal with pain. You could move the part of your body that is in pain, but I don't do that, especially if the instructor has just moved on to a new student and is telling them something very important about their work. You don't break the pose then. . . . So, you find ways to endure.—Eric

I've been in only one situation where people said, "Are you sure that you can hold that?" and, "Break if you need to." I didn't break it. It was because I had my arm up high, and standing for forty-five minutes it totally fell asleep because it was cut off. I was scared. You know, you get anxious. My brain wasn't functioning correctly I'm sure.—Denise

BEING STILL

In the past, studios might have used wood crutches or ropes hung from above to help models hold their poses. A model's hand, for example, might be

slipped through a loop in a rope and hoisted above her head so that the rope would hold the arm's weight. Today, however, these sorts of props are not generally used. Contemporary models are expected to hold their poses with only minimal help, from pillows or blankets arranged to cushion the points of contact between the body and the stand. While most models manage to hold their major body parts still, it is the ability to keep smaller parts still that marks a true professional. Fingers must remain in the same position; facial expressions must not change.

> You have to be in focus with what your toes are doing, what your fingers are doing, how your eyebrows are raised. . . . I can be so focused that I won't move. And they [artists] ask me, "Why don't you move?" and I say that I don't feel like I have to. If I've got to scratch my back, sometimes it's a challenge not to do it. I have to block it out.—Jonathan

> Well, being a good model, the complements that I have gotten are: "You don't move." And, I don't move.—Karen

> Movement during the session is the biggest taboo. I try not to move my head at all because the head can move in so many directions that remembering where you were is really difficult.—Russell

A model who assumes a pose and then, unconsciously, allows that pose to "slip," or drift, over the course of the session is considered sloppy. Models who are casual about moving or breaking a painful pose are considered unprofessional and unacceptable.

> I've heard of models who came into it, and they thought they could just sit there and sip coffee during their pose. That's totally unprofessional.—Eric

Most models agree that it is better to take simpler or more common poses that can be held than to attempt more complicated poses that might slip or have to be broken. Relatively small movements, followed by a quick resumption of the pose, are considered vastly preferable to breaking a pose completely. Most models told me that every once in a while, they had to make minor adjustments to a pose, release their neck, or shake out a hand. When they needed to move, models felt embarrassed and disappointed with themselves, either for selecting an inappropriate pose for the time allotted or for not being strong enough to endure the pain. Most models I spoke with also said they had been forced to completely break a pose at least once in the past, usually when they were still novice models.

Despite the intense concentration required to remain unmoving, and the pain involved, many models told me that being still had brought new peace, clarity, and meaning to their lives. Some felt that they had learned a lot about themselves through stillness and become more appreciative of themselves mentally and physically. For others, stillness took on a spiritual aspect.

I really have had my most spiritual and transcendent moments in being still. . . . It is amazing how the body becomes this channel for physical and emotional forces when you are still. And gravity, gravity has come to mean something to me that I never was sensitive to before.—Jason

Even pain some models said could aid in spiritual discovery and growth, providing a new pathway to awareness or harmony among mind, body, and spirit. Of course, the use of pain for spiritual growth is not unusual: the Bible is filled with examples, some religious people use self-mutilation or deprivation as part of their practice, and sadomasochists often report that what they seek through their pain is spiritual harmony and "oneness."[4]

BEING PRESENT

Ultimately, much of the success of a session comes down to what life models describe as "being present." In time, I learned that models could, in fact, "go away" during a pose in order to manage pain, but still "remain present" in the pose and the session. The contradiction was largely an issue of vocabulary. By being present, models meant being focused on what they were doing, and not being distracted by outside influences while in the studio. Being present was an attitude. Even the most graceful or athletic pose, held perfectly still, they explained, would be a failure if not accompanied by the proper mental aspect. For this reason, many models told me that they just could not work if they were depressed, angry, or upset by something going on in their lives.

I can't do it if I am depressed. Can't do it. . . . It's really hard for me to work when I am depressed. I mean really depressed, not just in a bad mood.—Nancy

When models went to sessions tired, upset, or just with a "closed" or negative attitude, they sometimes found it impossible to distract themselves from the pain of the pose.

If I'm irritated or agitated, all I can do is count. Count my breaths, one to ten, one to ten, one to ten . . . and try to guess how many minutes have gone by without checking the time. Sometimes it's just like you want to die. You just want to die.—Tracey

Models believe that doing a good job requires a constant and high level of self-awareness and self-monitoring—not just about what the body is doing but also about the effect of even subtle physical movements on the artists. The model's work is a complex balancing act, between thinking ahead to the next pose for a smooth transition and not thinking so much ahead that the focus on the current pose is lost. Artists, models explained, could tell when they were not "in" their pose, and in fact, their bodies might begin to shift toward the new pose.

If you are thinking too much about your next pose, you might actually start to move that way a little bit, which is taboo.—Russell

BEING COMMITTED

The lack of formal standards or any generally agreed upon prerequisites for being hired as a life model is a source of frustration to those models who consider themselves and their work professional. Almost all the models I met made a distinction between people who tried out modeling once or twice, usually while college students in need of cash, and those who worked at modeling as a trade or profession.

> *Occasionally there are people who do it and just need a little extra cash and do it on a whim a time or two and then that's it. But [for] the people who are really professional life models, it is dedication.—Robert*

According to professional life models, posing once or twice without making any effort to learn the craft does not make a person a life model, any more than planting a shrub makes a person a landscaper. Professional life models considered such itinerant workers a nuisance, because their willingness to work temporarily in poorer conditions and for lower wages made it difficult for professional models to demand more money or better conditions.

> *You know, they will hire anybody to keep wages down. Me, you have to pay me. I'm a professional. If you hire some girl or guy off the street, you may not have to pay them. . . . [T]hey'll take anything cause it's a new experience for them.—Karen*

In addition to undercutting the potential wages of professional life models, temporary models were also seen as a threat to the reputation of professional life models. College students posing nude for the "experience," or thrill, tend to like the bohemian, romanticized image of life modeling that is actually antithetical to the workaday lives of professional life models.

THE WILLAMETTE ART MODELS GUILD

One of the greatest obstacles to setting standards for both modeling and modeling conditions is the lack of communication among professional models. Models almost always work alone, without having had any group training. They know very little about what other models are doing or thinking. Portland area models were eager to talk with me, in part, I believe, because they wanted to find out what other models had told me.

When I first started interviewing models, several mentioned that there was an effort underway to bring together and organize Portland's professional life models, as models were already organized in a number of other sizeable

U.S. cities.[5] In the past, a number of newsletters had been printed and distributed by Portland models. But this new effort seemed to mark the first real attempt at something akin to unionization. Karen, a model who seemed to be spearheading the organization efforts, told me about the Willamette Art Models Guild. Early on, she said, the guild had been primarily social. Models had come together once every six weeks to talk about their work. For many, this was the first time they heard how other models viewed the job, particularly models of the opposite gender. By all accounts—and all of the models I spoke with knew of the Willamette Art Models Guild, even if they were not participants—the guild had some early successes. After being pressured by the guild, for instance, one local art school began giving art models access to its library and credit union, as well as discounted rates at a local athletic club and the Portland Art Museum's film screenings. These benefits were the standard benefits given to either students or employees of the school, so it is not clear whether the work of the guild actually obtained "new" benefits for life models or if they just pushed the institution into acknowledging that these benefits were available to life models as they were to any other employee. At the time of my interviews, however, the guild seemed to be slowing down. There had not been a meeting in a long time, and Karen herself was talking about leaving Portland. Conditions at many local schools remained deplorable.

Working Conditions

Models typically contrasted the working conditions at schools with the working conditions at private studios. At the time of my research, many Portland schools paid life models only $8.50 an hour, instead of $10, the going rate at private studios in town. In Los Angeles, by contrast, the average per-hour rate ranged between $15 and $18, while models in San Francisco made as much as $35 an hour.[6] Still, pay was not the primary complaint that Portland models had about working in local schools: they did not like the physical conditions. Above all, they abhorred the dirtiness of schools. While it might seem romantic to be an artist in a cluttered studio, with clay and paint on the floor, artists do not sit naked amongst this debris. Models particularly disliked the ubiquitous charcoal dust in school studios, which stuck to their bodies. Schools typically had little to offer in the way of clean padding, cushions, or sheets to cover the modeling stand. Models complained that school art departments provided inadequate heat, usually just one heater, instead of two, and that one often old or faulty.

> Just because I take off my clothes for money, doesn't mean I can work in any situation or that I am willing to work cold.—Karen

> Some artists want me to do poses where there's all kinds of intricate stuff, and if I can't stuff and prop and spend time fussing and spend time

accommodating. . . . If I don't get two inches worth [of padding] under that knee it will fall asleep, I promise you. Two inches worth of fabric will make the difference between a twenty-minute pose and a forty-five minute pose.—Liz

The local branch of the state university system was notorious among Portland's life models as the worst place to work locally. Several models told me that they simply would not work there, while most models commented on the school's poor conditions. Some complained that instructors failed to recognize them as professionals with skills, training, and experience. The payroll bureaucracy of the large school system added to their troubles; life models are accustomed to immediate payment, often in cash.

You have to jump through all kinds of hoops to get paid. You have to go to business offices to get paid. You have to sign all kinds of forms. Sometimes they're drafty and cold. Sometimes the teachers are cold, uncaring.—Victor

He did something very unprofessional the other day and was critiquing me while I was on the stand. He was drawing me and critiquing my pose. And I directly got in his face and said, "Never, never do that." And he hasn't spoken to me since.—Charles

While models do enjoy hearing praise from artists, most say that they can see for themselves when they have done a good job by the art that is created during the session or by the energy of the room.

Models mentioned one local private studio, run by two former life models, as the best place to model in the Portland area. Like other desirable studios, this one offered adequate heat, a toilet nearby, soap and a place to wash up, and something to drink and maybe eat. The studio also had a good stage, with sufficient props to create a variety of levels, and plenty of clean pillows, cushions, and sheets. The studio paid well. And most important, because the studio was run by models, there was an atmosphere of understanding and respect for the profession.

Deep visceral understanding of the process of modeling and how excruciating it can be and how revealing and intimate it is makes it an environment that is extremely model friendly.—Liz

Many life models in the Portland area got their start at this studio, where one of the owners would coach them through their first few sessions.

Prestige

Regardless of where a modeling session occurs, models believe that where the resulting artwork ends up determines the ultimate prestige of their work. Models are aware of the artistic marketplace and aspire to having "their work" do well in it.

I was flattered when one of the big guys down in San Francisco was having a retrospective of his figure art, and he used several paintings of me. He used one of me for the cover of the catalog and another for the announcement, and I was nothing but overwhelmed by flattery by that.—Jean

He did some extraordinary pieces of me, and they were published. He sent me a magazine that had them. He sent me postcards that advertised his show, and one of them was of me. The whole show was of me, so I was really flattered.—Rachel

During the time I was interviewing life models, the Portland Art Museum hosted an exhibit of Andrew Wyeth's paintings called the The Helga Pictures.[7] I spoke with a number of models about the exhibit. Most felt that it had in some way legitimized or helped to raise visibility and respect for life modeling work in the area.

When people go to see the Helga exhibit at the museum, they aren't saying "Where is the Wyeth collection?" They say, "Where's Helga?" I mean it's a weird form of near immortality.—Charles

Models realized that, outside of rare gallery exhibits, it was unlikely that works of art depicting their bodies would become truly famous. Still, they hoped something they had posed for might be considered great someday.

The reason why I like to model for a sculpture is because, in the end, the image they produce would be exceptionally long lived. I mean people centuries from now might potentially look at that and say, "Wow, I wonder who that was?"—Charles

Although they spent the majority of their time with young artists in training, models explained, they had to give their best performance no matter how bad the conditions of a session or how unskilled the artists, because it was always possible that they were, at that very moment, modeling for the next Picasso. Somewhere in that group, there was a potentially great artist who might never achieve greatness because on one particular day, in one particular studio, a model failed to inspire. It is this vigilance, this dedication to unknown artistic potential, this sense of responsibility to the world of art, which defines professional life modeling. While life models dreamed of having a special modeling relationship with a single famous artist, they did not long for sexual intimacy—the bohemian stereotype—but rather for the prestige or fame that can come from being an intimate part of the noble artistic process.

Research Notes

Modeling Life is the result of many years' study. I became interested in the topic, as described in the preface, in 1994. For the next year, I limited my research to exploring the literature and to speaking informally with artists and models. I moved to Portland, Oregon, in the fall of 1995 and shortly thereafter began formal interviews. Although I have spoken informally with many more life models, both inside and outside the city of Portland, I conducted formal interviews with thirty life models working in the Portland area. The formal interviews spanned a two-year period.

In the absence of any sort of directory, I used two different avenues for locating life models. First, I contacted local schools and studios to see if they would share the names and phone numbers of the models they had hired. One school simply copied their phone list for me. Most places, however, were not willing to give out that information. For these schools and studios, I provided stacks of stamped letters of introduction along with reply postcards. The school would address the envelopes and mail them out to the models on their list. The models receiving the letters could either call my office or return the reply card if they were willing to be contacted for the project.

Second, I used a simple snowball system. Many models knew of one or two other people who modeled in the area and were willing to either give me that model's contact information or to give the model my contact information. After I had been conducting interviews for a while, most models in the area had heard of the project and were interested in being interviewed. I was unable to reach a number of models either because they did not return phone calls and letters, or more often, because they had moved and not provided forwarding address information. No model I spoke with, however, refused to be interviewed. The models I interviewed ranged in age from twenty-one to the late sixties. Fourteen were male and the rest female. Education levels varied widely from no high school diploma, to a Harvard bachelor's degree, to graduate and professional degrees. Income levels varied similarly. Of the models I

interviewed, twenty-nine were Caucasian and one was African American. Although this small sample is probably not representative of life models in places such as New York City or Paris, I believe it is a good representation of Portland life models and as such provides a good vantage point from which to begin to understand the work and thinking of life models generally.

Each interview lasted between one and two hours, and each of the thirty models was interviewed once or twice. The interviews were semistructured: I had a list of topics that I tried to cover with every model that I interviewed. The order in which the topics were covered and the length of time spent on any given topic varied from interview to interview. I tried to maintain a conversational tone and encouraged models to speak freely and to redirect the discussion as seemed appropriate to them. Some interviews I conducted by myself, for others, I was accompanied by a student research assistant.

I tried to schedule initial interviews in quiet but public places, in order to put models at ease. Most initial interviews took place, therefore, in coffee houses around the Portland area. Follow-up interviews often took place in models' homes or at schools or studios where they were working. I did not pay models for their time, although I did usually buy them coffee and a snack of some sort.

I used a pen and notepad during interviews to make notes to myself of points that required clarification later in the interview. Other than this, however, I tried to minimize any writing so that I could maintain eye contact. Given the sensitive nature of much of the discussion, direct eye contact was essential to creating a sense of trust and privacy. The interviews were tape-recorded, usually on two different tape recorders.

I followed standard informed consent procedures with every model I interviewed or observed working. In addition, I obtained verbal consent from artists and instructors in classrooms and studios where I conducted observations. I have changed the models' names in the text of this book as a courtesy and to protect their privacy, although no model specifically requested this. Outside of formal interviews and observations, I have spoken with hundreds of people about their experiences modeling. These conversations were casual and often took place in response to presentations I have given on my research. I did not record these conversations, nor did I obtain signed consent forms on these occasions.

The cassette tapes from the formal interviews were transcribed, verbatim, by me or one of several student research assistants. This resulted in thousands of pages of dialog. In using quotations from this text, I have been careful to present the models' thoughts in their own words. I did, however, edit their words slightly. I removed the ubiquitous "ums," "you knows," and "likes" that appear unconsciously in our spoken language. I have also removed random or repeated words or false sentence starts, where doing so would not change the meaning of the original quote.

In addition to interviews, I spent many hours observing life models working in studios and schools. Usually, I would observe a model that I had already interviewed. Most observations I did on my own, although occasionally I would take a student research assistant with me so that I could check what I was seeing with what somebody else was seeing. In most cases, I would find an out of the way spot in the back of the room and sit for the session, most of which lasted about three hours. While observing, I took notes by hand.

In writing *Modeling Life*, I chose to focus on particular issues that were of interest to me as a sociologist who focuses her research on issues of sexuality. There are, of course, many other questions that might be asked that are quite different from those addressed here. Indeed, throughout the course of my work, I have been surprised by the broad range of people expressing interest in life models. Artists, of course, are particularly interested in knowing more about the people with whom they share their studio space. But life models raise questions about the nature of art and artistic production important to those studying philosophy and aesthetics as well. The history and changing role of life models call out to art historians. Life models' efforts to organize or unionize in various cities across the United States are ripe for labor studies. Indeed social scientists find myriad avenues of inquiry from the social construction of modesty or privacy, to the working of informal social networks, to the psychology of pain management, to the business issues of self-employment.

I have been most surprised by the interest of those outside of the art world and outside of the academy. Perhaps life models give us the opportunity to ask questions of ourselves: Could I do that? Could I be naked in front of so many people? Perhaps it is just the delight of discovering a world that has been right in front of us, unseen, for so long. Perhaps knowing about life models makes the paintings we see in museums a little less remote, a little more personal and human.

Notes

CHAPTER ONE. ASSUMING THE POSE: AN INTRODUCTION TO LIFE MODELING

1. For a discussion of how the social construction of inspiration has developed and changed over time, see especially John F. Moffitt, *Inspiration: The Cultural History of a Creation Myth* (Leiden: Brill, 2004).

2. A few examples of the many different approaches taken in the study of the nude include Kenneth Clark, *The Nude: A Study of Ideal Art* (London: Penguin, 1985, first published by John Murray, 1956); Carol Duncan, "The Esthetics of Power in Modern Erotic Art" *Heresies*, no. 1 (1977): 46–56; Ann Hollander, "Fashion in Nudity," *The Georgia Review* 30, no. 3 (1976): 642–73; and Norma Brude and Mary D. Garrard, eds., *The Expanding Discourse: Feminism and Art History* (New York: HarperCollins, 1992). This last book, a collection of feminist essays, offers many reflections on the nude as subject matter.

3. France Borel, *The Seduction of Venus: Artists and Their Models* (New York: St. Martin's, 1990); Frances Borzello, *The Artist's Model* (London: Junction Books, 1982).

4. Martin Postle and William Vaughan, *The Artist's Model: From Etty to Spencer*, exhibition catalog (London: Merrell Holberton, 1999); Dorothy Kosinski, *The Artist and the Camera: Degas to Picasso*, exhibition catalog (Dallas Museum of Art, 1999).

5. Borzello, *The Artist's Model*, 113.

6. Eduoard Lanteri, *Modeling and Sculpting the Human Figure* (Chapman Hall vol. 1 in 1902 and vol. 2 in 1904; reprint, New York: Dover, 1985), 88.

7. Borzello, *The Artist's Model*, 130.

8. Alice (Kiki) Prin, *The Education of a French Model: Kiki's Memoirs* (New York: Boar's Head, 1950).

9. See, for example, Anaïs Nin, *Little Birds* (New York: Pocket Books, 1979).

10. Borel, *The Seduction of Venus*, 96.

11. Alexander Liberman, *The Artist in His Studio* (New York: Viking, 1960).

12. Ernst Kris and Otto Kurz, *Legend, Myth, and Magic in the Image of the Artist: A Historical Experiment* (New Haven:Yale University Press, 1979).

13. Both of these scenarios were common in the past, particularly during the Renaissance period. Rudolf and Margot Wittkower, *Born under Saturn* (New York: Random House, 1963).

14. Borzello, *The Artist's Model*, 7.

15. What we consider to be a realistic portrayal of nudity is, of course, socially and culturally influenced and has changed over time and place.

16. Elizabeth Hollander, "Artists' Models" in *The Encyclopedia of Aesthetics*, ed. Michael Kelly (New York: Oxford University Press, 1998), 244.

17. Borel, *The Seduction of Venus*, 139.

18. John Moffitt, *Caravaggio in Context: Learned Naturalism and Renaissance Humanism* (Jefferson, NC: McFarland, 2004), 8.

19. Peter Steinhart, *The Undressed Art: Why We Draw* (New York: Knopf, 2004), 114.

20. Ilaria Bignamini and Martin Postle, *The Artist's Model: Its Role in British Art from Lely to Etty*, exhibition catalog (Nottingham: Goater and Son and Nottingham University Art Gallery, 1991), 9.

21. Bignamini and Postle, *The Artist's Model*, 10.

22. Nikolaus Pevsner, *Academies of Art Past and Present* (Cambridge: Cambridge University Press, 1940; reprint New York: DaCapo, 1973).

23. Borzello, *The Artist's Model*, 17.

24. Pevsner, *Academies of Art Past and Present*, 231.

25. Martin Postle and William Vaughan, *The Artist's Model: From Etty to Spencer*, exhibition catalog (London: Merrell Holberton, 1999).

26. Borzello, *The Artist's Model*, 20.

27. Bignamini and Postle, *The Artist's Model*, 11.

28. Hollander, "Artists' Models," 245.

29. Postle and Vaughan, *The Artist's Model*, 10.

30. Borel, *The Seduction of Venus*, 66; see also Elizabeth Hollander, "Working Models," *Art in America* May (1991): 152–55.

31. W. Friedlander, *Caravaggio Studies* (New York: Schocken, 1969), cited in Moffitt, *Caravaggio in Context*, 42.

32. Joel Swerdlow, "Vincent van Gogh: Lullaby in Color" *National Geographic*, 192, no. 4 (1997): 112.

33. Borzello, *The Artist's Model*.

34. Borel, *The Seduction of Venus*, 149–50.

35. Billy Klüver and Julie Martin, "A Short History of Modeling," *Art in America* May (1991): 156–83.

36. Borzello, *The Artist's Model*, 97.

37. Borzello, *The Artist's Model*, 93–94.

38. Clifton D.Bryant and Eddie Palmer, "Massage Parlors and 'Hand Whores': Some Sociological Observations," *The Journal of Sex Research* 11, no. 3 (1975): 227–41.

39. Steinhart, *The Undressed Art*, 118.

40. David Sellen, *The First Pose: 1876: Turning Point in American Art, Howard Roberts, Thomas Eakins, and a Century of Philadelphia Nudes* (New York: Norton, 1976).

41. Marilyn Stokstad, *Art History* (New York: Abrams, 1995), 1001.

42. Klüver and Martin, "A Short History of Modeling."

43. Postle and Vaughan, *The Artist's Model*, 10.

44. Terms for particular eras in artistic production—*modernism, impressionism, postimpressionism*—are inexact and used inconsistently. I use terms such as *expressionism* here in a general way, to refer to an artistic form and subject matter that contrasts with that of earlier periods.

45. Hollander, "Artists' Models," 243, 246.

46. Hollander, "Artists' Models," 246.

47. Robert Speller, "The Fine Art of Keeping Still, for a Price," *New York Times*, September 6, 1993, late edition, p. 9.

48. Hollander, "Artists' Models," 248.

49. Clark, *The Nude*, 2.

CHAPTER TWO. RETURNING THE GAZE: OBJECTIFICATION AND THE ARTISTIC PROCESS

1. Linda Nochlin, *Women, Art, and Power* (New York: Harper and Row, 1998), 2.

2. Katie Roiphe, *The Morning After: Sex, Fear, and Feminism* (Boston: Little, Brown, 1993). Roiphe argues against efforts to include leering or looking in definitions of sexual harassment.

3. Laura Mulvey, "Visual Pleasure and Narrative Cinema," *Screen* 16, no. 3 (1975): 6–18.

4. John Berger, *Ways of Seeing* (British Broadcasting, 1972; reprint New York: Penguin Books, 1977), 47.

5. Borel, *The Seduction of Venus*, 91.

6. Mulvey, "Visual Pleasure and Narrative Cinema," 11.

7. Auguste Rodin, *L'arte* interviews collected by P. Gsell, cited in Borel, *The Seduction of Venus*, 152.

8. Timon Oefelein, "Yes It's Photography: But Is It Art?" *The Photographic Journal* 137, no. 5 (1997), 193.

9. Marshall Battani. "Organizational Fields, Cultural Fields and Art Worlds: The Early Effort to Make Photographs and Make Photographers in the 19th Century United States of America," *Media, Culture and Society* 21, no. 5 (1999). Battani has written a careful analysis of the cultural production of the profession of photography in nineteenth-century America.

10. Oefelein, "Yes It's Photography," 193.

11. Terry Barrett, *Criticizing Photographs*, 2nd edition (Mountain View, CA: Mayfield, 1996), 148.

12. Stephen Bull, "Culture Leash: Exploring Common Ground between Art and Camera Club Photography," *Creative Camera* 357 (1999): 10–13.

13. Oefelein, "Yes, It's Photography."

14. Glen Vallance, "Photography as Art: Yes!" *PSA Journal* 6 (June, 1999): 10.

15. Susan Sontag, *On Photography* (New York: Farrar, Straus, and Giroux, 1977), 148.

16. Susan Brown and Dale Durfee, "Calendar Queen: From Garage Wall to Refined Collectable Fine Art, the Nude Calendar Has Come a Long Way," *The British Journal of Photography* 7241 (1999): 16–17.

17. Among the best known discussions of art and cultural capital is that of theorist Pierre Bourdieu. "Symbolic capital" Bourdieu argues, "finds its favourite refuge in the domain of art and culture, the site of pure consumption—of money, of course, but also of time convertible into money." Pierre Bourdieu, *Outline of a Theory of Practice*, trans. Richard Nice (Cambridge: Cambridge University Press, 1997), 197.

18. Lynda Nead, "The Female Nude: Pornography, Art and Sexuality," *Signs: Journal of Women in Culture and Society* 15, no. 2 (1990), 329.

19. Charles Desmarais, quoted in Woodward, "It's Art, but Is It Photography?" 46.

20. Berger, *Ways of Seeing*, 21.

21. Berger, *Ways of Seeing*, 21.

22. Nadine Strossen, *Defending Pornography: Free Speech, Sex, and the Fight for Women's Rights* (New York: Scribner, 1995), 55.

23. Strossen, *Defending Pornography*, 103.

24. Liza Mundy, "The New Critics," *Lingua Franca* Sept./Oct. (1993): 26–33, cited in Strossen, *Defending Pornography*, 23.

25. Joyce Price, "Art Professor Escapes Discipline: Vanderbilt Says He Must Warn Classes," *Washington Times* March 21, 1993, cited in Strossen, *Defending Pornography*, 26.

26. State v. Henry, 302 Ore. 510, 732 P. 2d 9 (1987).

27. Shange Ntozake, "Where Do We Stand on Pornography" *MS Magazine*, Jan./Feb. (1994): 34, cited in Strossen, *Defending Pornography*, 23.

28. See as one example Dorothy Kosinski, *The Artist and the Camera: Degas to Picasso*, catalog of an exhibition held at the San Francisco Museum of Modern Art, Oct. 2, 1999–Jan. 4, 2000, the Dallas Museum of Art, Feb. 1–May 7, 2000, and the Fundacion del Museo Guggenheim, Bilbao, June 12–Sept. 10, 2000. Copyright 1999 Dallas Museum of Art, distributed by Yale University Press.

29. Sontag, *On Photography*, 4. Sontag argues that although photographs may seem to capture "reality" in a way unavailable to paintings, photographs are in fact as much an interpretation of the world as are paintings.

30. Joel Snyder and Neil Walsh Allen, "Photography, Vision, and Representation," *Critical Inquiry* 2, no. 1 (1975): 152; emphasis in original.

31. The legitimation of nudity turns out to be a central activity of the art studio and central concern of every life model, as is described in chapters 4 and 5.

32. Berger, *Ways of Seeing*, 54.

CHAPTER FOUR. DEFINING THE LINE: SEXUAL WORK VERSUS SEX WORK

1. Clinton J. Jesser and Louis P. Donovan, "Nudity in the Art Training Process: An Essay with Reference to a Pilot Study," *The Sociological Quarterly* 10 (1969): 355.

2. Marilyn Salutin, "Stripper Morality," *Trans-Action* 8 (1971): 15.

3. Sociologists Gresham Sykes and David Matza make this argument regarding the deviant behaviors of juvenile delinquents in "Techniques of Neutralization: A Theory of Delinquency" *American Sociological Review* 22 (December, 1957): 664–70.

4. In the 1950s, American Sociologist Erving Goffman popularized a theoretical approach among sociologists, commonly called "symbolic interactionism." This approach is concerned with the ways in which the participants in any given setting will cooperate in maintaining the definition of that setting. Later, Harold Garfinkel advocated using "breaching experiments" or norm violation experiments as a means of uncovering our taken-for-granted cooperative interaction patterns. Garfinkel, also an interactionist, was a founder of the "ethnomethodological" approach, and author of *Studies in Ethnomethodology* (Englewood Cliffs, NJ: Prentice Hall, 1967).

5. See Joan P. Emerson, "Behavior in Private Places: Sustaining Definitions of Reality in Gynecological Examinations" in *Recent Sociology No. 2: Patterns of Communicative Behavior*, ed. Hans Peter Drietzal (New York: Macmillan, 1970). Nowhere is this cooperative interaction more starkly revealed than during a vaginal examination. In the United States, women over the age of eighteen are advised to see a gynecologist annually for a pelvic exam and pap smear. Under any other circumstances, the insertion of a stranger's fingers into the vagina of a woman would be considered sexual assault or sexual intercourse. Sexual assault is likely to leave a woman traumatized and emotionally distressed and to require a significant period of healing; sexual intercourse is accompanied by feelings of pleasure, well-being, and desire. The vaginal exam, while incorporating the very same physical action, prompts neither of these reactions from a woman.

CHAPTER FIVE. MAINTAINING THE LINE: COPING WITH CHALLENGES TO THE "SERIOUS WORK" DEFINITION

1. Emerson, "Behavior in Private Places," 91.

2. James M. Henslin and Mae A. Biggs, "Dramaturgical Desexualization: The Sociology of the Vaginal Examination," in *Studies in the Sociology of Sex*, ed. James Henslin (New York: Appleton-Century-Crofts, 1971), 152.

3. Henslin and Biggs, "Dramaturgical Desexualization," 257.

4. Jesser and Donovan, "Nudity in the Art Training Process."

5. Georg Simmel, "Sociology of the Senses: Visual Interaction," in *Introduction to the Science of Sociology*, ed. Robert E. Park and Ernest W. Burgess (Chicago: University of Chicago Press, 1924).

6. Jesser and Donovan, "Nudity in the Art Training Process," 358.

7. Jesser and Donovan, "Nudity in the Art Training Process."

8. Jesser and Donovan, "Nudity in the Art Training Process."

9. Fred Davis, "Deviance Disovowal: The Management of Strained Interaction by the Visibly Handicapped," *Social Problems* 9, no. 2 (1961): 123.

10. Henslin and Biggs, "Dramaturgical Desexualization," 259.

11. Judith Long Laws and Pepper Schwartz, *Sexual Scripts: The Social Construction of Female Sexuality* (Hinsdale, IL: Dryden, 1977), 43.

12. Weinberg, "The Nudist Management of Respectability," 342.

13. Jesser and Donovan, "Nudity in the Art Training Process."

14. Henslin and Biggs, "Dramaturgical Desexualization."

15. Henslin and Biggs note similar interactions in medical settings where personnel may refer to the present patient in the third person. "Such ignoring of the presence of a third person would ordinarily constitute a breach of etiquette for middle-class interactions, but in this case there really isn't a third person present. The patient has been 'depersonalized' and, correspondingly, the rules of conversation change, and no breach of etiquette has taken place." See Henslin and Biggs, "Dramaturgical Desexualization," 264.

16. Martin Weinberg, "Sexual Modesty, Social Meanings, and the Nudist Camp," *Social Problems* 12, no. 3 (1965): 311–18.

17. Craig J. Forsyth, "Parade Strippers: A Note on Being Naked in Public," *Deviant Behavior: An Interdisciplinary Journal* 13 (1992): 391–403.

CHAPTER SEVEN. MODELING GENDER: SOCIAL STIGMA, POWER, AND THE PENIS

1. Erving Goffman, *Stigma: Notes on the Management of Spoiled Identity* (New York: Simon and Schuster, 1963), 4.

2. Some researchers, such as Jacqueline Boles and Albeno Garbin, "The Choice of Stripping for a Living: an Empirical and Theoretical Explanation," *Sociology of Work and Occupations* 1, no. 1 (February 1974): 110–23, have found that women who strip make more money stripping than they would at other jobs for which they are qualified.

3. The gendered experience of life is no longer an empirical question but has become, instead, a background assumption around which other research questions are framed. Therefore, I was surprised when life models repeatedly told me that they thought modeling was the same for men and women, despite acknowledging a cultural preference for female models and for particular poses by men and women, and the fact that models' own descriptions of their experiences suggest that there are some very real differences based upon gender. Few, perhaps, had talked in detail with models of the opposite sex. Perhaps, too, they were asserting their professional boundaries when they denied gender differences, arguing that professional modeling follows a certain form, regardless of the gender of the person taking the pose. To suggest that modeling might differ for men and women might have seemed to introduce a sexual element, which could threaten professionalism.

4. Of course, there are sanctions for women who step too far outside the normative female roles, and the latitude women are given expands and contracts over time. Nor should women's greater range of self-expression be mistaken for greater power: patriarchy remains the norm, and women may be allowed a greater range of emotional expression simply because that expression does not threaten male hegemony in any way.

5. This manipulation of social stigma is in keeping with the ideas of Robert Gramling and Craig J. Forsyth, who argue that individuals can exploit their stigma in order to alter the outcomes of various social exchanges. See "Exploiting Stigma," *Sociological Forum* 2 (1987): 401–15.

6. Gramling and Forsyth, "Exploiting Stigma," 406.

7. Berger, *Ways of Seeing*, 46.

8. M. Warr, "Fear of Victimization: Why Are Women and the Elderly More Afraid?" *Social Science Quarterly* 65 (September, 1984): 681–702; "Fear of Rape among Urban Women," *Social Problems*, 32 (February, 1985): 238–50. According to Warr's research, rape is feared more by young American women than any other crime, and women often perceive situations as more dangerous or risky than men do.

9. Craig Forsyth, "Parade Strippers"; Clifton D. Bryant, *Sexual Deviancy and Social Proscription: The Social Context of Carnal Behavior* (New York: Human Sciences, 1982).

10. Sometimes in long poses, during which a model will take breaks or leave for hours or days, the artist will put tape on the stand to mark where the model's feet, legs, arms and hands were. This helps the model in assuming the same position again upon his or her return.

CHAPTER TEN. BEING PRESENT: GETTING GOOD AT IT

1. One model told me about a guide to modeling that he had read, which he described as a brief monograph put out by an art school. I was never able to locate a copy of this or any other how-to guide for life modeling.

2. Borzello, *The Artist's Model*, 36.

3. Borel, *The Seduction of Venus*.

4. Kim Hewitt "Pain as a Pathway to Social and Spiritual Identity," in *Mutilating the Body: Identity in Blood and Ink* (Bowling Green: Bowling Green State University Popular Press, 1997), 27–40. See also Nancy Breaux and Sarah Phillips, *More Than a Pervert*, a feature-length documentary on the sadomasochism subculture in Portland, Oregon. Premiered, Forest Grove, OR, Pacific University, April, 1, 1999.

5. Chris Richards, "Naked Ambition: Models Get Organized," *Washington Post*, May 8, 2003, C05.

6. Karin Lewicki "The Secret Life of Life Models" LA Alternative Press 2, no. 11 (2003), http://www.laalternativepress.com/v02n11/features/feature.php (accessed 16 February 2005).

7. From October 6, 1996 to January 12, 1997, the Portland Art Museum hosted the exhibit Andrew Wyeth: The Helga Pictures.

Bibliography

Ames, Richard G., Stephen W. Brown, and Norman L. Weiner. "Breakfast with Topless Barmaids." In *Observations of Deviance*, edited by Jack D. Douglas. New York: Random House, 1970.

Anspach, R. Renee. "Notes on the Sociology of Medical Discourse: The Language of Case Presentation." *Journal of Health and Social Behavior* 29 (1988): 357–75.

Arnold, David O. *The Sociology of Subcultures*. Berkeley, CA: Glendessary, 1970.

Barney, Glaser. "Awareness Contexts and Social Interaction." *American Sociological Review* 33 (1968): 46–62.

Barrett, Terry. *Criticizing Photographs*, 2nd edition. Mountain View, CA: Mayfield, 1996.

Battani, Marshall. "Organizational Fields, Cultural Fields and Art Worlds: The Early Effort to Make Photographs and Make Photographers in the 19th Century United States of America." *Media, Culture and Society* 21, no. 5 (1999): 601–26.

Beck, Christina S., and Sandra L. Ragan. "Negotiating Interpersonal and Medical Talk: Frame Shifts in the Gynecological Exam." *Journal of Language and Social Psychology* 11, nos. 1–2 (1992): 47–61.

Becker, Howard S. "History, Culture and Subjective Experience: An Exploration of the Social Bases of Drug-Induced Experiences." *Journal of Health and Social Behavior* 8 (1967): 163–76.

———. *Art Worlds*. Berkeley: University of California Press, 1982.

Berger, John. *Ways of Seeing*. British Broadcasting Corporation, 1972; reprint, New York: Penguin Books, 1977.

Berger, Peter, and Thomas Luckman. *The Social Construction of Reality*. New York: Doubleday, 1966.

Betterton, Rosmary, ed. *Looking On: Images of Femininity in the Visual Arts and Media*. London: Pandora, 1987.

Bignamini, Ilaria, and Martin Postle. *The Artist's Model: Its Role in British Art from Lely to Etty*. Exhibition catalog. Nottingham University Art Gallery, 1991.

Boles, J., and A. P. Garbin. "The Choice of Stripping for a Living: An Empirical and Theoretical Explanation." *Sociology of Work and Occupations* 1, no.1 (February 1974): 110–23.

―――. "The Strip Club and Stripper-Customer Patterns of Interaction." *Sociology and Social Research* 58, no. 2 (1974): 136–44.

Borel, France. *The Seduction of Venus: Artists and Their Models.* New York: St. Martin's, 1990.

Borzello, Frances. *The Artist's Model.* London: Junction Books, 1982.

Brackley, Judith. "Male Strip Shows: Where Women Are Finding Laughs, Gasps, and a Night Out." *MS.* 9 (November 1980): 68–70, 84.

Broude, Norma, and Mary D. Garrad, eds. *The Expanding Discourse: Feminism and Art History.* New York: HarperCollins, 1992.

Brown, Susan, and Dale Durfee. "Calendar Queen: From Garage Wall to Refined Collectable Fine Art, the Nude Calendar Has Come a Long Way." *The British Journal of Photography* 7241 (1999): 16–17.

Bryant, Clifton D. *Sexual Deviancy in Social Context.* New York: New Viewpoints, 1977.

―――. *Sexual Deviancy and Social Proscription: The Social Context of Carnal Behavior.* New York: Human Sciences, 1982.

Bryant, Clifton D., and Eddie Palmer. "Massage Parlors and 'Hand Whores' Some Sociological Observations." *The Journal of Sex Research* 11, no. 3 (1975): 227–41.

Bull, Stephen. "Culture Leash: Exploring Common Ground between Art and Camera Club Photography." *Creative Camera* 357 (1999): 10–13.

Bulliet, C. J. *The Courtezan Olympia: An Intimate Study of Artists and Their Models.* New York: Covici Friede, 1930.

Carey, Sandra, Robert A. Peterson, and Louis K. Sharpe. "A Study of Recruitment and Socialization into Two Deviant Female Occupations." *Sociological Symposium* 11 (1974): 11–24.

Clark, Kenneth. *The Nude: A Study of Ideal Art.* John Murray, 1956; reprint, London: Penguin Books, 1985.

Davis, Fred. "Deviance Disavowal: The Management of Strained Interaction by the Visibly Handicapped." *Social Problems* 9, no. 2 (1961): 120–32.

D'Encarnaco, Paul, Peter Parks, Kathy Tate, and Pat D'Encarnacao. "The Significance of Streaking." *Medical Aspects of Human Sexuality* 8 (1974): 159–60, 165.

Douglas, Jack D., ed. *Observations of Deviance.* New York: Random House, 1970.

Dreitzel, Hans Peter, ed. *Recent Sociology 2: Patterns of Communicative Behavior.* New York: Macmillan, 1970.

Dressel, Paula L. and David M. Petersen. "Becoming a Male Stripper: Recruitment, Socialization, and Ideological Development." *Work and Occupations* 9, no. 3, (1982): 387–406.

———. "Gender Roles, Sexuality, and the Male Strip Show: The Structuring of Sexual Opportunity." *Sociological Focus* 15, no. 2 (1982): 151–62.

Duncan, Carol. "The Esthetics of Power in Modern Erotic Art." *Heresies* 1 (1977): 46–56.

Eberhard, Kronhausen. *The Complete Book of Erotic Art*, vols. 1 and 2. New York: Bell, 1978.

Emerson, Joan P. "Behavior in Private Places: Sustaining Definitions of Reality in Gynecological Examinations." In *Recent Sociology No. 2: Patterns of Communicative Behavior*, edited by Hans Peter Drietzal. New York: Macmillan, 1970.

———. "Nothing Unusual Is Happening." In *Symbolic Interaction: A Reader in Social Psychology*, third edition, edited by Jerome G. Manis and Bernard N. Meltzer. Boston: Allyn and Bacon, 1978.

Fletcher, Joseph. *Situation Ethics: The New Morality*. Philadelphia: Westminster, 1966.

Forsyth, Craig J. "Parade Strippers: A Note on Being Naked in Public." *Deviant Behavior: An Interdisciplinary Journal* 13 (1992): 391–403.

Friedlander W. *Caravaggio Studies*. New York: Schocken, 1969.

Friedson, Eliot. *Patients' Views of Medical Practice*. New York: Sage, 1961.

Garb, Tamar. "The Forbidden Gaze." *Art in America* (May, 1991): 147–51, 186.

Garfinkel, Harold. *Studies in Ethnomethodology*. Englewood Cliffs, NJ: Prentice Hall, 1967.

Gernsheim, Helmut. *A Concise History of Photography*, 3rd edition. New York: Dover, 1986.

Goffman, Erving. *The Presentation of Self in Everyday Life*. Garden City, NY: Anchor Books, 1959.

———. *Behavior in Public Places: Notes on Social Organization of Gatherings*. New York: Free Press, 1963.

———. *Stigma: Notes on the Management of Spoiled Identity*. New York: Simon and Schuster, 1963.

———. *Interaction Ritual: Essays on Face-to-Face Behavior*. Chicago: Aldine, Publishing Company, 1967.

———. *Gender Advertisements*. The Society for the Anthropology of Visual Communication, Washington, 1976; reprint, Cambridge, Massachusetts: Harvard University Press, 1979.

———. *Forms of Talk*. Philadelphia: University of Pennsylvania Press, 1981.

Gramling, Robert, and Craig J. Forsyth. "Exploiting Stigma." *Sociological Forum* 2 (1987): 401–15.

Gross, Edward, and Gregory P. Stone. "Embarrassment and the Analysis of Role Requirements." *American Journal of Sociology* 70, no.1 (1964): 1–15.

Handelman, David. "Nude Awakenings." *Premiere* (June 1997): 31–35.

Henslin, James M., and Mae A. Biggs. "Dramaturgical Desexualization: The Sociology of the Vaginal Examination." *Studies in the Sociology of Sex*, edited by James Henslin. New York: Appleton-Century-Crofts, 1971.

Henslin, James M., and Edward Sagarin. *The Sociology of Sex*. New York: Schocken, 1978.

Hewitt, Kim. "Pain as a Pathway to Social and Spiritual Identity." Chapter 2 in *Mutilating the Body: Identity in Blood and Ink*. Bowling Green: State University Popular Press, 1997.

Hochschild, Arlie. *The Managed Heart: Commercialization of Human Feeling*. Berkeley: University of California Press, 1983.

Hollander, Anne. "Fashion in Nudity." *The Georgia Review* 30, no. 3 (1976): 642–73.

———. *Seeing through Clothes*. New York: Viking, 1978.

Hollander, Elizabeth. "Working Models." *Art in America* (May, 1991): 152–55.

———. "Artists' Models." In *The Encyclopedia of Aesthetics*, edited by Michael Kelly. New York: Oxford University Press, 1998.

Hong, Lawrence K., and Robert W. Duff. "Becoming a Taxi-Dancer." *Sociology of Work and Occupations* 4, no. 3 (1977): 327–43.

Hospers, John. "Aesthetics." In *The Encyclopedia of Philosophy*, Vol. 1, edited by Paul Edwards. New York: Macmillan and Free Press, 1967.

Jesser, Clinton J., and Louis P. Donovan. "Nudity in the Art Training Process: An Essay with Reference to a Pilot Study." *The Sociological Quarterly* 10 (1969): 355–71.

Kasson, Joy S. "Narratives of the Female Body: The Greek Slave." In *The Culture of Sentiment*, edited by Shirley Sammuels. New York: Oxford University Press, 1992.

Klüver, Billy, and Julie Martin. "A Short History of Modeling." *Art in America* (May 1991): 156–83.

Kosinski, Dorothy. *The Artist and the Camera: Degas to Picasso*. Catalog of an exhibition held at the San Francisco Museum of Modern Art, Oct. 2, 1999–Jan. 4, 2000, the Dallas Museum of Art, Feb. 1–May 7, 2000, and the Fundacion del Museo Guggenheim, Bilbao, June 12–Sept. 10, 2000. Copyright 1999 Dallas Museum of Art, distributed by Yale University Press.

Kris, Ernst, and Otto Kurz. *Legend, Myth and Magic in the Image of the Artist: A Historical Experiment*. New Haven: Yale University Press, 1979.

Lanteri, Edouard. *Modeling and Sculpting the Human Figure*. Chapman Hall, Ltd. vol. 1 in 1902 and vol. 2 in 1904; reprint, New York: Dover, 1985.

Laws, Judith Long, and Pepper Schwartz. *Sexual Scripts: The Social Construction of Female Sexuality*. Hinsdale, Illinois: Dryden, 1977.

Lewicki, Karin. "The Secret Life of Art Models." LA Alternative Press, 2 no. 11, 2003, http://www.laalternativepress.com/v02n11/features/feature.php (accessed February 16, 2005).

Liberman, Alexander. *The Artist in His Studio.* New York: Viking, 1960.

Manis, Jerome G., and Bernard N. Meltzer, eds. *Symbolic Interaction: A Reader in Social Psychology.* Boston: Allyn and Bacon, 1978.

Miller, Gaje. *Odd Jobs: The World of Deviant Work.* Englewood Cliffs, NJ: Prentice-Hall, 1978.

Moffitt, John F. *Caravaggio in Context: Learned Naturalism and Renaissance Humanism.* Jefferson, NC: McFarland, 2004.

———. *Inspiration: The Cultural History of a Creation Myth.* Leiden: Brill, 2004.

Mulvey, Laura. "Visual Pleasure and Narrative Cinema." *Screen* 16, no. 3 (1975): 6–18.

Mundy, Liza. "The New Critics." *Lingua Franca* (September/October 1993): 26–33.

Murray, Alexander S. *Who's Who in Mythology: Classic Guide to the Ancient World.* New York: Bonanza Books, 1989.

Muschamp, Herbert. "Don't Look Now." *Vogue* 181, no. 2 (1991): 318–21, 357.

Nead, Lynda. "The Female Nude: Pornography, Art, and Sexuality." *Signs: Journal of Women in Culture and Society* 15, no. 2 (1990): 323–35.

Newhall, Beaumont. *The History of Photography: From 1839 to the Present Day.* New York: Museum of Modern Art, 1937; reprint, New York: Museum of Modern Art; distributed by Doubleday, 1964.

Nin, Anaïs. *Little Birds.* New York: Pocket Books, 1979.

Nochlin, Linda. *Women, Art, and Power.* New York: Harper and Row, 1988.

Ntozake, Shange. "Where Do We Stand on Pornography?" *MS Magazine* (January/February 1994): 32–41. Cited in Strossen, Nadine. *Defending Pornography: Free Speech, Sex, and the Fight for Women's Rights.* New York: Scriber, 1995.

Oefelein, Timon "Yes It's Photography: But Is It Art?" *The Photographic Journal* 137, no. 5 (1997): 192–96.

Oregonian. "Modeling Costs Art Teacher His Catholic School Job." June 13, 1996, wire stories, sunrise edition, A18.

Patrinos, Angela. "Sculpture I." *The New Yorker*, July 24, 1995.

Peretti, Peter O., and Patrick O'Connor. "Effects of Incongruence between the Perceived Self and the Ideal Self on Emotional Stability of Stripteasers." *Social Behavior and Personality* 17 no. 1 (1989): 81–92.

Peterson, David M., and Paula L. Dressel. "Equal Time for Women: Social Notes on the Male Strip Show." *Urban Life* 11, no. 2 (1982): 185–208.

Pevsner, Nikolaus. *Academies of Art Past and Present.* Cambridge: Cambridge University Press, 1940; reprint, New York: Da Capo, 1973.

Pizzini, Franca. "Communication Hierarchies in Humour: Gender Differences in the Obstetrical/Gynecological Setting." *Discourse and Society* 2, no. 4 (1991): 477–88.

Postle, Martin, and William Vaughan. *The Artist's Model: From Etty to Spencer.* Exhibition catalog. London: Merrell Holberton, 1999.

Price, Joyce. "Art Professor Escapes Discipline: Vanderbilt Says He Must Warn Classes." *Washington Times*, March 21, 1993.

Prin, Alice (Kiki). *The Education of a French Model: Kiki's Memoirs.* New York: Boar's Head Books, 1950.

Pudor, Heinrich. "Nudity in Art Life." *Journal of Homosexuality* 22, no. 1–2 (1991): 109–13.

Richards, Chris. "Naked Ambition: Models Get Organized." *Washington Post* May 8, 2003.

Roebuck, J., and S. L. Spray. "The Cocktail Lounge a Study of Heterosexual Relations in a Public Organization." *American Journal of Sociology* 72, no. 4 (1967): 388–95.

Roebuck, Julian B., and Wolfgang Frese. "The After-hours Club." *Urban Life* 5 (1976): 131–64.

Roiphe, Katie. *The Morning After: Sex, Fear and Feminism.* Boston: Little, Brown, 1993.

Ronai, Carol Rambo, and Carolyn Ellis. "Turn-Ons for Money: Interactional Strategies of the Table Dancer." *Journal of Contemporary Ethnography* 18 no. 3 (1989): 271–98.

Rubington, Earl, and Martin S. Weinberg. *Deviance: The Interactionist Perspective,* 4th edition. New York: Macmillan, 1981.

Sagarin, Edward. *Deviance and Social Change.* Beverly Hills, CA: Sage, 1977.

Salutin, Marilyn. "Stripper Morality." *Trans-Action* 8 (1971): 12–22.

Scott, Marvin B., and Stanford M. Lyman. "Accounts." *American Sociological Review* 33 (1968): 46–62.

Sellen, David. *The First Pose: 1876: Turning Point in American Art, Howard Roberts, Thomas Eakins, and a Century of Philadelphia Nudes.* New York: Norton, 1976.

Shrum, Wesley, and John Kilburn. "Ritual Disrobement and Mardi Gras: Ceremonial Exchange and Moral Order." *Social Forces* 75, no. 2 (1996): 423–58.

Simmel, Georg. "Sociology of the Senses: Visual Interaction." In *Introduction to the Science of Sociology,* edited by Robert E. Park and Ernest W. Burgess. Chicago: University of Chicago Press, 1924.

Skipper, James K., and Charles H. McCaghy. "Stripteasers: The Anatomy and Career Contingencies of a Deviant Occupation." *Social Problems* 17 (1970): 391–405.

Snyder, Joel, and Neil Walsh Allen. "Photography, Vision, and Representation." *Critical Inquiry* 2, no. 1 (1975): 143–69.

Sontag, Susan. *On Photography.* New York: Farrar, Straus and Giroux, 1977.

Speller, Robert. "The Fine Art of Keeping Still, for a Price." *New York Times* September 6, 1993, late edition.

Steinhart, Peter. *The Undressed Art: Why We Draw.* New York: Knopf, 2004.

Stokstad, Marilyn. *Art History.* New York: Abrams, 1995.

Strossen, Nadine. *Defending Pornography: Free Speech, Sex, and the Fight for Women's Rights.* New York: Scriber, 1995.

Swatos, William H., and Judith A. Kline. "The Lady Is Not a Whore: Labeling the Promiscuous Woman." *International Journal of Women's Studies* 1, no. 2, (1978): 159–66.

Swerdlow, Joel L. "Vincent Van Gogh: Lullaby in Color." *National Geographic* 192, no. 4 (1997): 100–29.

Sykes, Gresham, and David Matza. "Techniques of Neutralization: A Theory of Delinquency." *American Sociological Review* 22 (December 1957): 664–70.

Ullerstam, Lars. *The Erotic Minorities: A Swedish View.* London: Calder and Boyars, 1967.

Vallance, Glen. "Photography as Art? Yes!" *PSA Journal* 6 (June, 1999): 10.

Velarde, Albert J., and Mark Warlick. "Massage Parlors: The Sensuality Business." *Society* 11 (1973): 63–74.

Warr, M. "Fear of Victimization: Why Are Women and the Elderly More Afraid?" *Social Science Quarterly* 65 (September 1984): 681–702.

———. "Fear of Rape among Urban Women." *Social Problems* 32 (February 1985): 238–50.

Weigts, Weis, Hanneke Houtkoop, and Patricia Mullen. "Talking Delicacy: Speaking about Sexuality during Gynecological Consultations." *Sociology of Health and Illness* 15, no. 3 (1993): 295–314.

Weinberg, Martin S. "Sexual Modesty, Social Meanings, and the Nudist Camp." *Social Problems* 12, no. 3 (1965): 311–18.

———. "The Nudist Management of Respectability." In *Deviance: An Interactionist Perspective*, edited by Earl Rubington and Martin S. Weinberg. New York: Macmillan, 1981.

Wilmerding, John. *Andrew Wyeth: The Helga Pictures.* New York: Abrams, 1987.

Wittkower, Rudolf and Margot. *Born under Saturn: The Character and Conduct of Artists: A Documented History from Antiquity to the French Revolution.* New York: Random House, 1963.

Woodward, Richard B. "It's Art, But Is It Photography?" *New York Times Magazine*, October 9, 1988.

Ziller, Robert G. *The Social Self: Schemas of the Self and Significant Others.* New York: Pergamon, 1971.

Index

abominations of the body, 75
abstractionism, 8, 125n44
abstract sexuality, 38–39
acrobatics, 10, 30
active versus passive models, 14–15, 30–31, 56
active versus passive poses, 78–79, 108
Adderly, Charles, 5
agents, models as, 15–17
age of models, 9
Allen, Neil Walsh, 25
Andersen, Hans Christian, 43
Angels and Insects (film), 3
Apelles's, 4
arousal, 39–40, 87–89, 92
art academies, history of, 4–8, 9
art community
 acceptance of nudity, 82
 bohemian image/culture, 6–7, 37, 82, 95, 114
 friendships outside of, 80–82
 models as part of, 82–83, 97–98
Artist and the Camera (Kosinski), 2
artistic creativity
 elevation of nudity in service to, 35–36
 and looking at the model, 55
 models' views of process, 44–45
 photography versus, 18–19
 and sexual arousal, 39–40, 87
 source of, 1–2
 See also inspiration

artists
 considering point of view of, 98–99
 embarrassment of, vii, 55, 61, 63
 gender of, 37, 39
 looking at the model, 54–58, 125n2
 opinions of life models, 104
 respectful practices for, 66–67
 See also posing for individual artists
Artists and Models (magazine), 3
Artist's Model, o' Eve before the Fall, An (Hall), 7
Artists Model, The (1999 exhibit), 2
Artist's Model (Borzello), 2
art models guild, 114–15
art studios
 cooperative interaction in, 35–37, 127n4–5
 in Europe, 4–8
 and human sexuality, 38–39
 male artists/male model ratio, 78
 models' preference for, 9
 socializing in, 45, 53–54, 64–67
 stigma management strategies, 77–80
 working conditions, 46–47, 64–65, 109–10, 116
ateliers, 6, 7–8
attitude, importance of, 112–14

Balzac, Honoré de, 3
Barrett, Terry, 18–19
being present, 30, 65, 113–14
Berger, John, 14, 19, 25, 84

141

posing process (continued)
erotic nature of, 87–89
gender differences, 78–80
human sexuality, 38–39
looking, 54–58, 125n2
menstrual bleeding and, 63–64
mental aspects, 10, 30–31, 71, 106–7
models as collaborators, 15–17
models as objects, 12–15, 73
model's control in, 10, 56, 107
models' privacy, 43, 46–47, 61
models referred to in third-person,
65–66
pain as part of, 93, 107, 109–11, 113
photography and, 23, 25, 93
planning ahead, 10, 93, 99, 105–9
self-exploration, 31–33, 112–13
and sexual arousal, 39–40, 87–89, 92
and talking or socializing, 45, 53–54,
64–67
taping position for long poses, 88,
130n10
unacceptable poses, 41, 59–60
See also life model skills
postimpressionism, 125n44
Postle, Martin, 4–5
power of nudity, 83–85
power structures, portrayal of, 14
prestige, model's hope for, 3, 47, 116–17
Prin, Alice, 3
privacy
asserting right to, 43
erections and, 61
in studio setting, 46–47
profession, entering the, 28–29, 103–4
professionalism
erection prevention techniques,
62–63
itinerant workers versus, 114
pain management techniques,
99–100, 110–11
planning ahead as, 10, 93, 99, 105–9
setting standards for, 114–15
stigma management strategies,
77–80
See also legitimation of model's role;
life model skills

prostitutes and prostitution
reality of, 35
as social attribution, 6, 7, 37, 76
whore versus, 42
putative blemishes of individual charac-
ter, 75

rape, fear of, 86, 130n8
realism versus idealism, 4
Real Thing (James), 3
recognition, model's hope for, 3, 47,
116–17
reference photographs, 22–23
Renaissance, 4–5, 124n13
Rodin, Auguste, 17
Roman culture, 1, 4

safety while modeling, 85–87
scene production. See posing process
Seduction of Venus, The (Borel), 2
self-image, developing a positive, 72–73,
83–85
Sellen, David, 7
sensual characteristics of paints or clay,
24
sensual versus sexual expression, 38, 43,
59–60
sexual arousal, 39–40, 87–89, 92
sexual harassment, 14, 125n2
sexual inequality
and dominant gaze, 76–77
effect of, 14–15, 40, 77–79, 84
latitude of women and male hegemo-
ny, 130n4
sexual versus sensual expression, 38, 43,
59–60
sex work
family's view of life modeling as,
71–72, 80
prostitution, 6, 7, 35, 37, 76
strippers, 35, 40–42, 76, 95
whores, 42
signature poses, 108
sliding-scale payment schedule, 100–101
Snyder, Joel, 25
social constructions
art as expression of, 14